LIVE STEAM

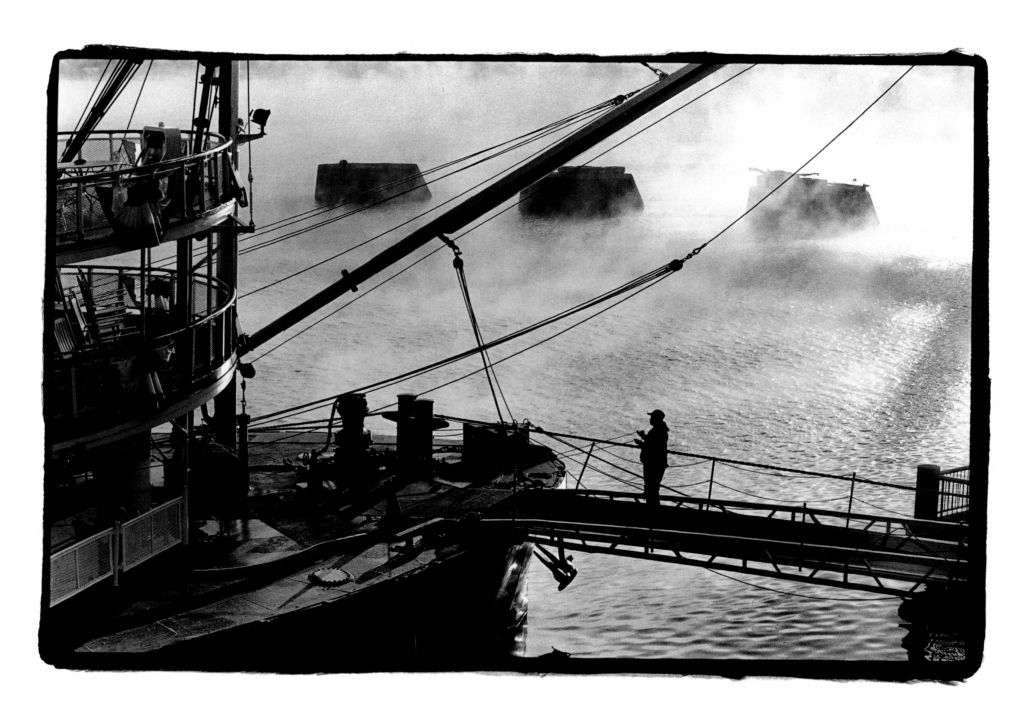

LIVE STEAM

Paddlewheel Steamboats on the Mississippi System

A Photographic Tribute By

JON KRAL

Text by Jon Ward

LONG WIND PUBLISHING
Ft. Pierce, Florida

Also by Jon Kral: *Cracker, Florida's Enduring Cowboys,* **ISBN 0-9658128-7-1**
Hotbloods, Beyond the Winner's Circle, **ISBN 0-9658128-8-X**

First Printing, 2000

Designed and Edited by Jon Ward (with thanks to John Barry)

Library of Congress Cataloging-in-Publication Data

Kral, Jon, 1946-
Live Steam: Paddlewheel Steamboats on the Mississippi System
1. Steamboats-Mississippi River 2. Mississippi River-Navigation 3. Transportation
4. Photography-Artistic I.Kral, Jon II. Title
Library of Congress Catalog Card Number 00-102746
ISBN 1-892695-00-6

Photographs Copyright 2000 by Jon Kral
Text Copyright 2000 by Jon Ward

Published by Long Wind Publishing
2208 River Branch Drive
Ft. Pierce, Florida, 34981
(561) 595-0268 fax: (561) 595-6246 e-mail: LongWndPub@tctg.com
www.LongWindPub.com

Printed in Hong Kong

For Pop, who showed me love
For Ted, who gave me life
For the Bear, who taught me how to work

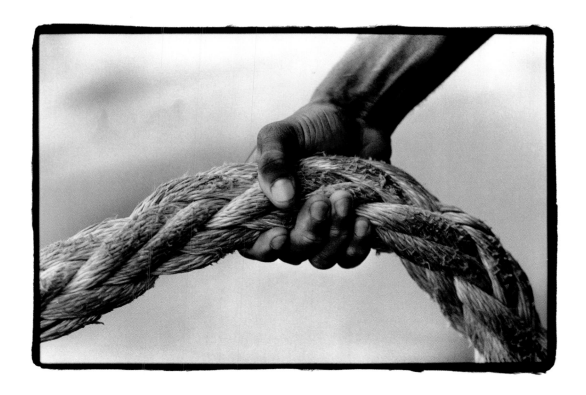

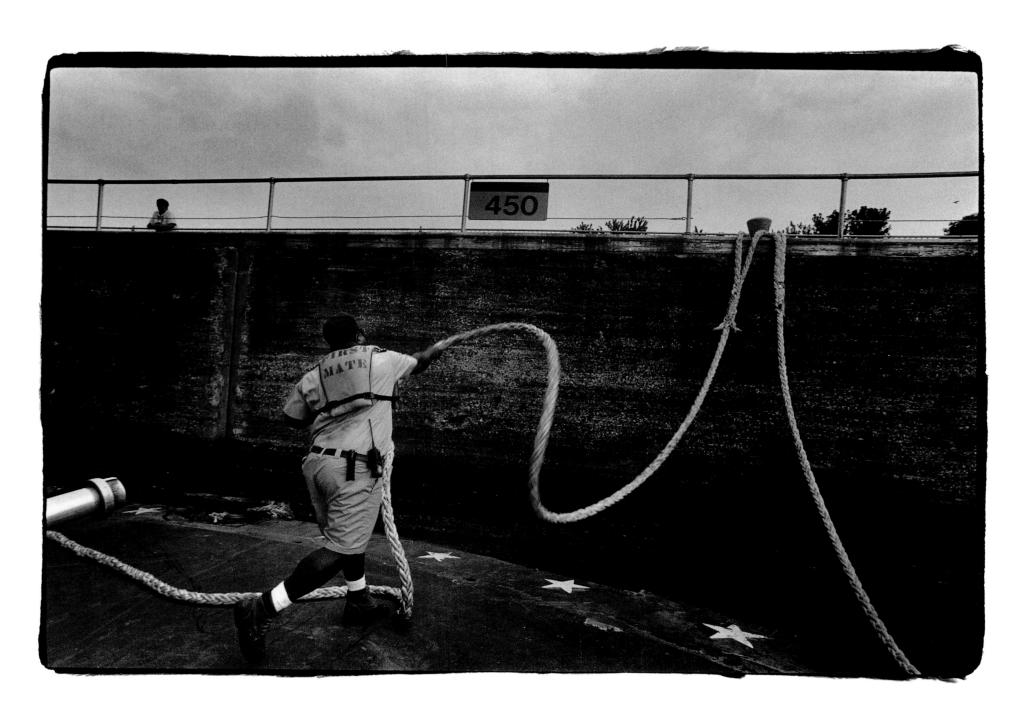

ACKNOWLEDGMENTS

The Mississippi River is composed of hundreds of streams and rivers, each one contributing to the wonder that eventually becomes the "Father of the Waters." So it is with this project.

Growing up on the banks of the Mississippi in Memphis, the feel of the River runs deep within me. Now, I've been fortunate enough to meet someone with an extraordinary talent to convey that feeling in his art: Jon Kral. We produced some other fine books before we got around to my personal favorite, but, thanks, my friend. It was well worth the wait.

As Jon and I spent time exploring the steamboats in this volume, we encountered others with an equal love for them. They did everything they could to help us bring this story to you.

Our sincerest appreciation goes to the Delta Queen Steamboat Company of New Orleans for giving us absolute access to all of their boats and crews. Scott Young, then the company president, had an enthusiasm for the project which filtered down through the Delta Queen staff at every level. Particular appreciation goes to Lucette Brehm and Terri Monaghan at the New Orleans headquarters, and to the officers and crews aboard their vessels who put up with us crawling around at all hours of the day and night, for weeks. Special thanks goes to the staff at Litton's Avondale (LA) Shipyard for helping us with the drydock shots.

We discovered true keepers of the historic flame aboard the *Belle of Louisville* in Louisville, KY. Even their wharfboat, the *Mayor Andrew Broaddus*, is on the National Historic Register. We particularly want to thank Anne Jewell and Captains Mike Fitzgerald and Eddie Mattingly.

Captain Carl Henry of the *Julia Belle Swain* and Captain Steve Nicoulin of the *Natchez* were both apologetic that their respective vessels were undergoing needed layup and repair when we visited, but we were able to record them and their fine crews as they labored to maintain these prizes. It was exactly what we had hoped for.

I'd like to personally thank the Miami Herald for allowing Jon Kral to undertake this project.

Finally, we want to express our appreciation to our families and friends who let us go forth on these little adventures, secure in the knowledge that we have a safe harbor to return to.

Jon Ward

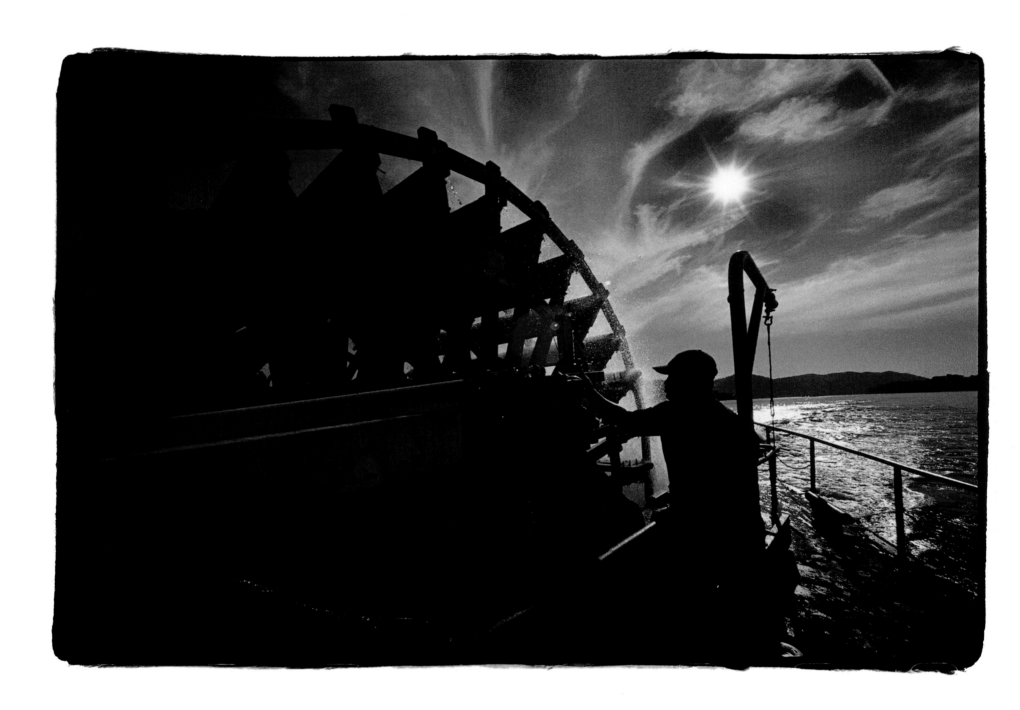

"Long may the lonely six survivors last, for they are as American as apple pie and the Fourth of July!"
Captain Clark C. "Doc" Hawley

Down-bound, the *Mississippi Queen* paddled resolutely into the lock chamber of the U. S. Corps of Engineers' Lock and Dam Number 24 at Clarksville, Missouri, on the Upper Mississippi River. Backing her paddlewheel and deliberately grinding her starboard rub rail into the unyielding concrete walls of the chamber, she slowed to a halt. Her deck crew sprang to life, grabbing up the thick braided hawsers that had been "faked out" on the foredeck beforehand and deftly began tossing them around the moveable mooring pins that would secure out craft in place. The river water began to drain out from underneath her wide, flat bottom.

Out on the wing bridge, Captain Paul Thoeny cast a practiced eye down the boat's flank to make sure all was in order. Pilot Gene Tronier stood by in the pilothouse, ready to relay orders to the Chief, Ed Gaskill, below in the engine room.

On deck, First Mate Alan Johnson was on patrol, overseeing the activities of his mostly-young deckers, and all was right with the world.

As we began our descent into the moist greenish-brown

darkness of the lock, I thought about what naval architect Alan Bates (designer of the steamboat *Natchez IX*) had written in a note to me, about working on river steamboats.

"I am glad that you are doing this study of work on the excursion boats. Too much has been written about the romantic plashing of the paddlewheel." he said. "The general perception is that the crews have a sort of permanent vacation. Nothing could be farther from the truth."

"Hardest work I ever did was on the river," multiple Grammy-winning musician John Hartford ("Gentle on My Mind") chimed in. "Coldest, wettest, hungriest, most mosquito bitten, sleepiest, happiest, horniest, maddest, most puzzled, most illuminated and most scared I've ever been has been on the river."

"Yep." agreed Captain Robert E. "Bobby" Powell, who's been piloting on the Mississippi system for over 51 years. "That's what I know about the river . . . by the time you think you know it all, it will turn and make an ass of you. You'll never be a good pilot if you don't have a good excuse handy."

It's true that it can be awfully easy to slip into a romantic state of mind when gliding along on the "Father of The Waters," feet propped up on the railing and a cool beverage in hand.

I talked with ships' carpenter Craig Hall in his orderly shop down in the lower engine room of the *Delta Queen*. He was building a fancy new mahogany swing for the cabin deck of the *DQ*.

"You'd be amazed at how many romances will start or be renewed on the swings on these decks."

Actually, I wouldn't be surprised at all.

There is another side to the coin, however.

"One is not an excursion boatman if he has never placated or overcome an aggressive drunk." Alan Bates commented. "Until a man has cleared away wall-to-wall potato salad after a junior high school educational field trip, he is no excursion boatman. Unless a porter has spent a half-hour up to his armpits in a clogged water closet, he ain't no porter! And deckhands on passenger boats must ring a mooring pin with a two-inch line from twenty feet the same as those who work on towboats."

John Hartford remembered regularly "a cloud of mosquitoes so thick it looked like steam from the cook-house!"

Chief Mike Pfleider also reminded me of the blast furnace August day in 1999, when the temperature on his deck on the *Belle of Louisville* hit a record-setting 175 degrees.

So there, you romantics!

Lee "Fatboy" Havlik, mate on the *Julia Belle Swain*, was reading a maintenance manual to two other crew members as they labored over a broken feed-water pump. "This happens all the time." he said. Parts were spread out all over the *Julia Belle's* first deck while she stood tied up and broke down on the landing at Prairie du Chien, WI. "For every hour of steaming, there's seven or eight hours of prep work and logistics . . . and repairs." he sighed.

Alan Bates, again: "Along with endurance, the riverman must be resourceful beyond the norm, for the elements respect no man and breakdowns never occur at the landing."

"There's a lot of hard work to keep a steamboat operating in the 21st Century, and there's a reason why there aren't many like this left." says Captain Carl Henry of the Great River Steamboat Company, owners of the *Julia Belle Swain*. "In a day and age when it's simpler and quicker to travel from point A to point B by many other means, river travel has been relegated to that of a historical sidebar, a tourist attraction, a destination in itself."

So, why is it worth all the fuss and bother?

"The old days are gone now," Captain Henry continued, "but people seem to need them more and more. Riding one of the last passenger steamboats in the country does more than take people out for a ride on the river. It takes people back in time, to a different place. A place before television and computers and cell phones and faxes and the Internet. It slows people down and creates a time for reflection. And that's what seems to appeal to the passengers the most."

The steamboat is also an American original.

"The paddlewheel steamboat was strictly a "Yankee" invention, and was America's first contribution to the Industrial Revolution." said Captain Clark C. "Doc" Hawley, *dean emeritus* of American steamboating, having served as Captain aboard the *Belle of Louisville, Delta Queen, Natchez, Mississippi Queen* and *American Queen* in a

career spanning almost fifty years and untold miles on the Mississippi River system.

"In the realms of social and economic influence, it was, in many ways, the most notable achievement of our industrial infancy."

"This book concerns the behind-the-scenes realities of the six remaining steamboats on those rivers which empty into the Mississippi and extend over some 15,000 miles of navigable waters." noted Hawley, "Among those miles, many thousands of steamers made their way. During the 'golden era' of river travel, from 1830-1860, the docks of New Orleans saw fifty to sixty steamboat arrivals daily." he commented. "Now, there are only six steamers operating on the entire system."

"The six that remain are an interesting mix of new and old, steel and wood, slow and fast. All sternwheelers. All passenger carriers. All are Twentieth Century boats whose very existences confirm the tenacity of steamboat romance carried over into the 21st Century."

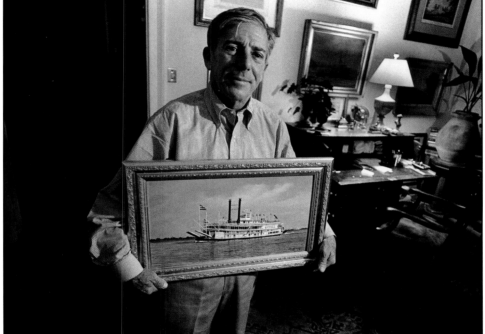

I spent an afternoon relaxing in the main lounge of the *Delta Queen,* tied up to the landing at Point Pleasant, WV, discussing the lure of river work with 84-year-old Captain Charles Stone.

"I guess I never was much of a student." he demurred. "In school, if I had a pencil, I 'd just push it around on the desk, and I'd have me a boat. Went to work with my daddy before I was tall enough to see out of the pilothouse windows. Earned my Operators License in 1936."

I asked Captain Stone, now retired but still revered on the Great Kanawha River, if he ever missed the life.

Eyes clouding up, he gave me a wistful smile and replied, "Nightimes . . . in dreams . . . I still boat."

Of the six surviving steamers, three, the *Belle of Louisville,* the *Julia Belle Swain,* and the *Natchez ,* carry short-term day excursionists. The other three, the *Delta Queen, Mississippi Queen,* and *American Queen,* offer passengers luxurious overnight lodging and fine dining.

On the excursion boats, crew members are always expected to do double duty. Deckhands and engineers also serve as bartenders and entertainers.

On the overnight boats, the crews are vastly larger, having to accommodate the requirements of hotel and restaurant services in addition to the running of the boat, which is handled by separate deck, engineering and navigation crews.

As on all boats, crew quarters are tight and efficiently designed, dorm-style. Rooms with individual bathrooms are scarce and assigned to senior staffers.

The hotel and restaurant crew members usually work seven days a week, four to six weeks on and two weeks off. The days always run ten to twelve hours, always on your feet.

"It's smaller than the smallest town you can think of, below decks." says Carolyn Devitt, 27, bar steward. "It's a very accepting atmosphere in a lot of ways, but you have to leave all of your little intolerances on the dock."

"Boat life", as the crew calls it, is not for everyone. Turnover, especially among the entry levels of the hotel and restaurant staff, is high. Many times, one year in grade qualifies you as a senior staffer.

"Situations do tend to get magnified by the confined space." stated Lead Deckhand Hunter Smith, who suggested that the lifestyle would be a good subject for someone's Master's Thesis in Sociology.

"You give it six weeks, and you're hooked." declared bartender Michael Furr, 28. "If you get past the

first month, you'll come back. When I got off the boat the first time in Cincinnati, I swore I'd never come back! The first week off was fine. After the second, I couldn't wait to come back."

Ellie Downer, a cabin attendant on the *Delta Queen* agreed. After fourteen years with the company, "twelve on this deck," Miss Ellie is well known by many repeat passengers, who greet her cordially in the morning.

"I'm never going to retire." she stated flatly. "I'll just die right here, and join the ghost on the other side." she said, referring to the fabled spirit of Captain Mary Greene, reputed to still walk the decks of the *DQ*.

"She's more of a poltergeist, really." judged Miss Ellie, who then recounted a series of her encounters with the visitor from beyond the veil.

"It's not that working a good eight-to-five job behind a desk somewhere is particularly unappealing. But there's the fear that a person could actually get used to it." declares Captain Henry of the *Julia Belle Swain*, convincingly.

"My first river work was aboard the Avalon ." offered Captain Hawley. "It was a rough-and-tumble, floating-carnival existence . . . the seven-month 'season' saw the faithful old boat paddling through seventeen states by way of eight, sometimes nine, rivers. Leaving our home port of Cincinnati in April, we would return for only one week in June, and not return again until October,"

"A return (from the *Delta Queen*), in 1970, to my old *Avalon* , now renamed the *Belle of Louisville,* was like 'going home' to the three-hour excursion crowd," he continued, "but without the grueling 'tramping' schedule. For the first time in my career, I had a normal day to day existence, with just two trips daily and every night in Louisville."

So, why do they do it?

Captain Carl Henry: "This old steamboat seems to have an effect on people that other boats can't. And maybe that's precisely why we value its existence so much. Everyone in the crew is aware of the significance of what we do, our place in a larger history, and the tradition we are helping to uphold. And, it's a completely different job out here from any traditional job on shore; everyday adventures and mishaps give way to camaraderie and a fierce pride and sense of purpose in everything that we do. To us, it's an honor and a privilege to be a part of the great fraternity and brotherhood that is the modern-day riverman."

"When her boilers are fired and her hundred-year old engines hiss and crank into action, the *Belle of Louisville* literally comes to life." smiles her Master, Captain Mike Fitzgerald. "Her steam touches your senses. She huffs and puffs and draws you to her. With a gentle rocking motion, the *Belle* cradles her passengers and connects them to centuries past."

John Hartford: "I have a fond memory of coming up through Utica Bend above Peru on a beautiful sun-drenched day, below the old lift bridge, where the old grain elevator kinda leans out into the river, a little kinda like the Leaning Tower of Utica, and wondering . . . how anyone could be any happier."

Jon Ward
Ft. Pierce, FL

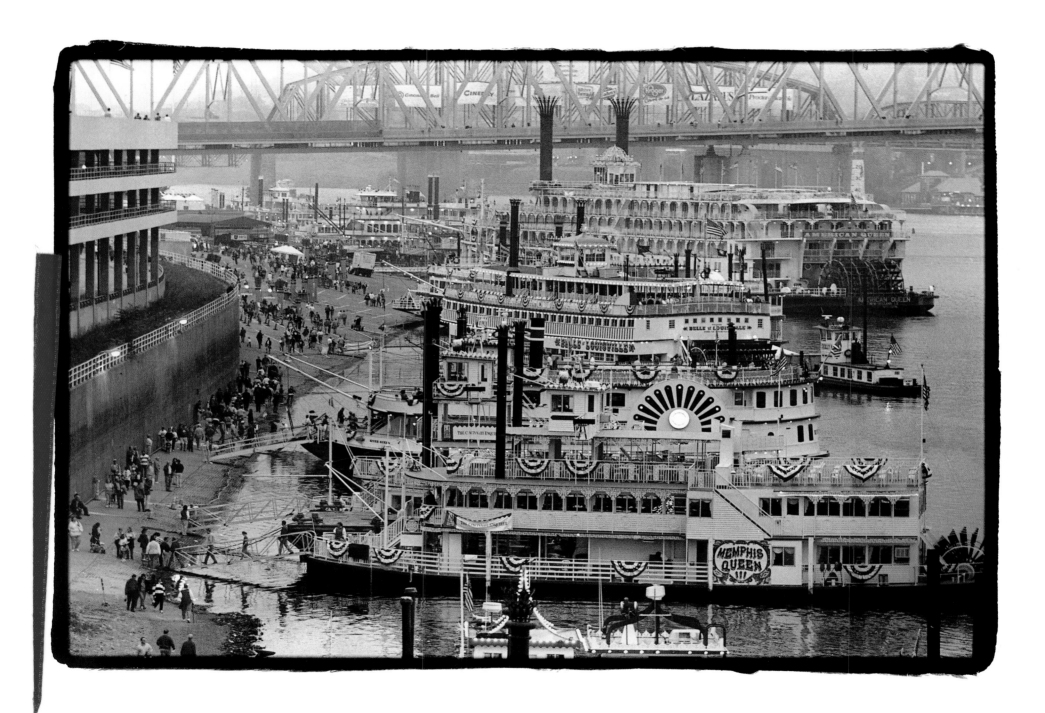

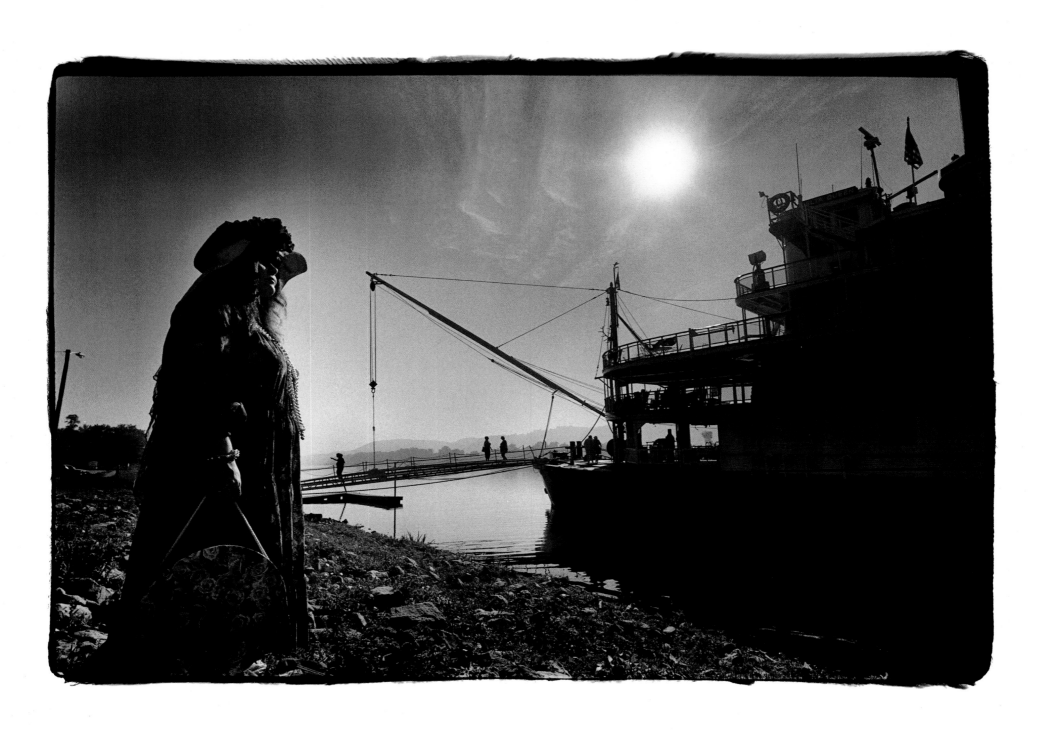

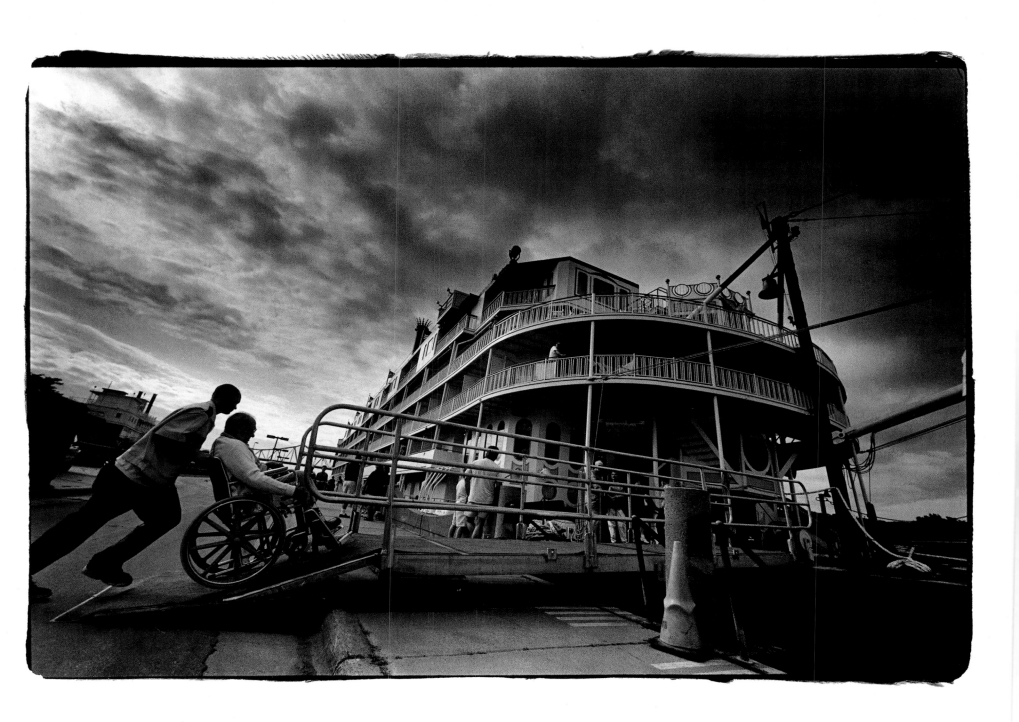

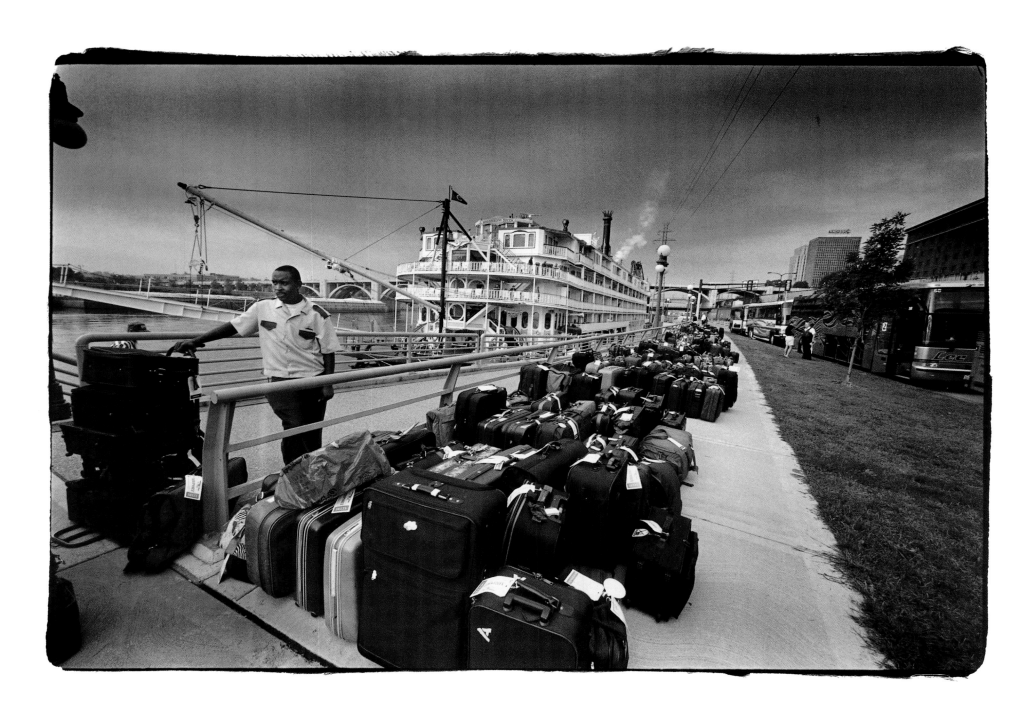

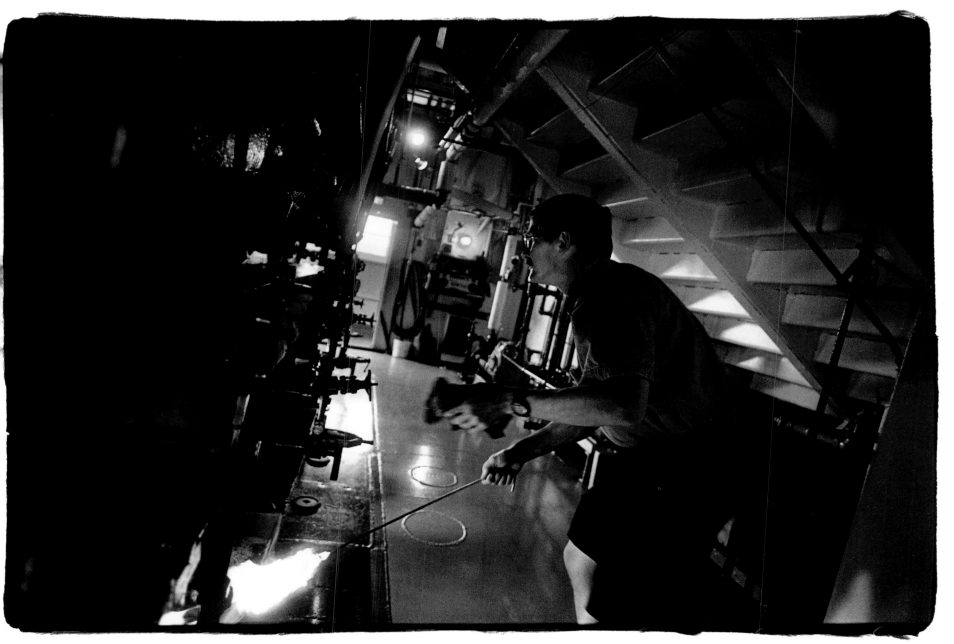

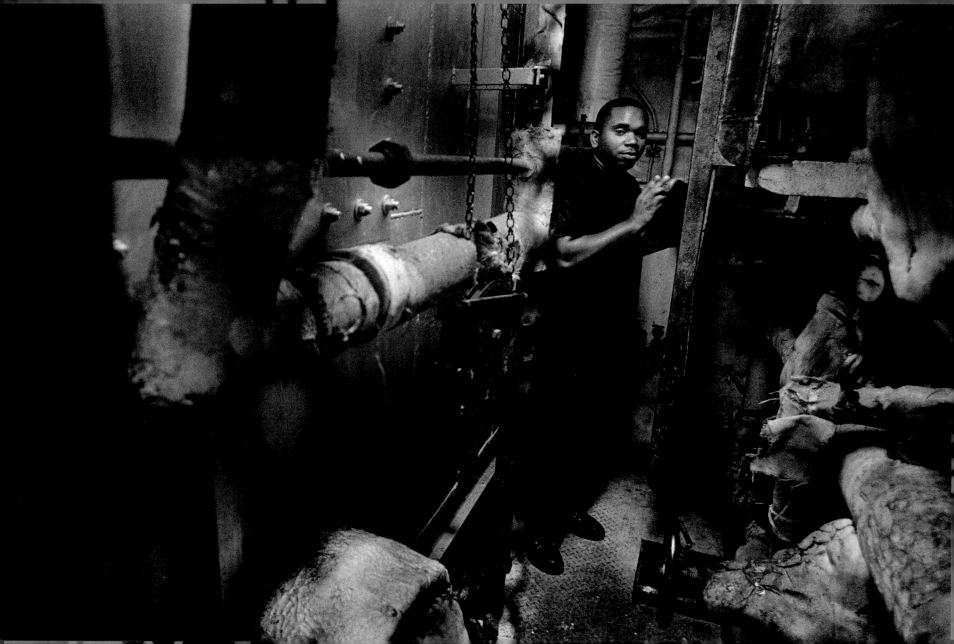

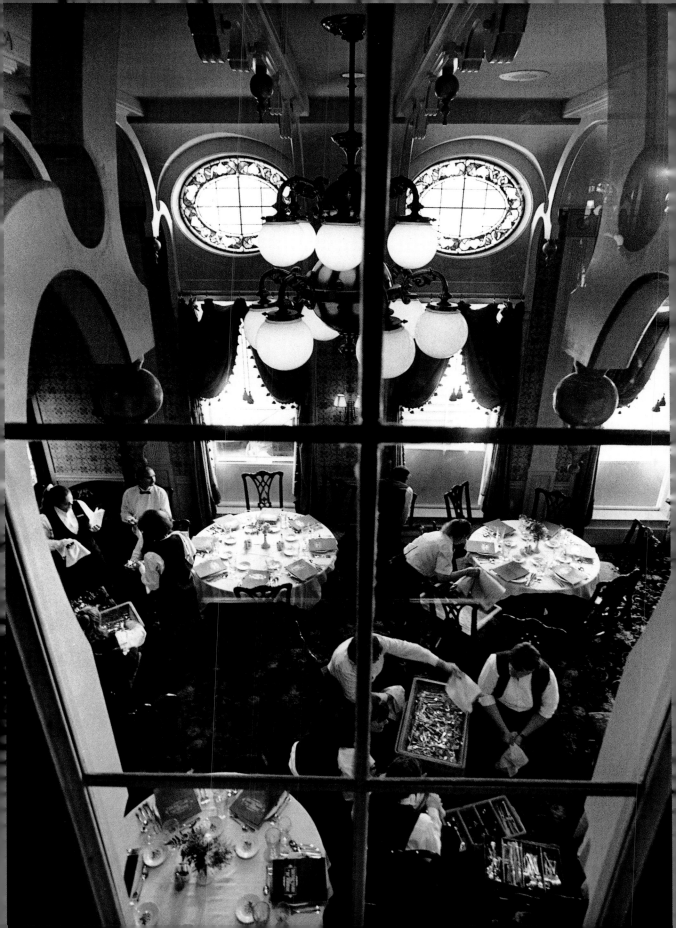

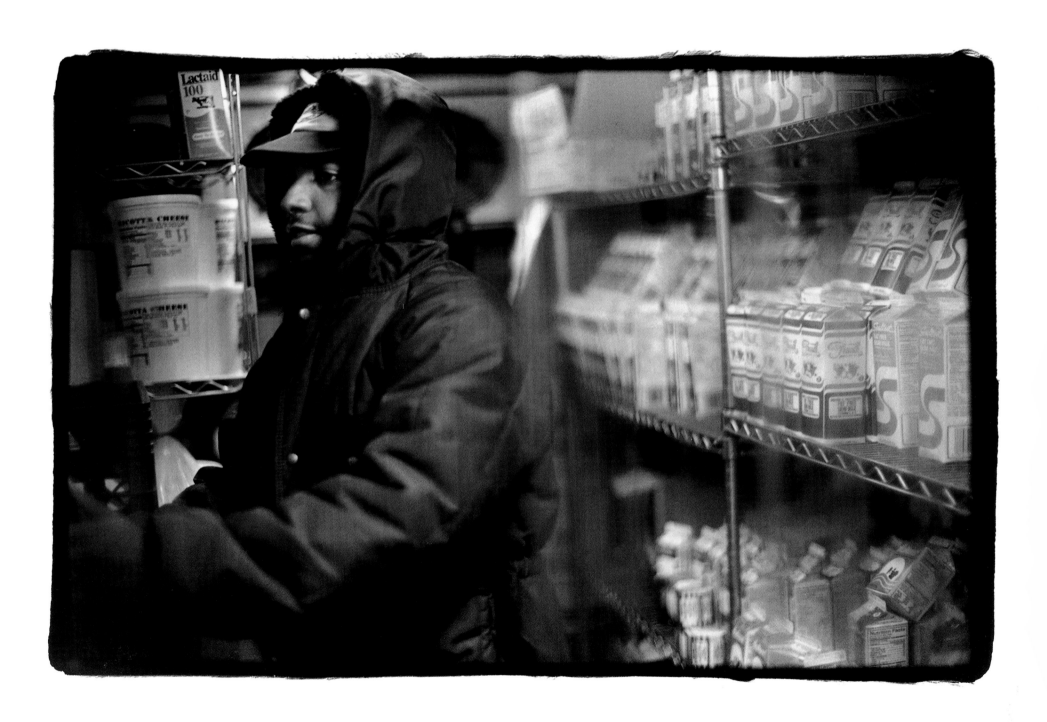

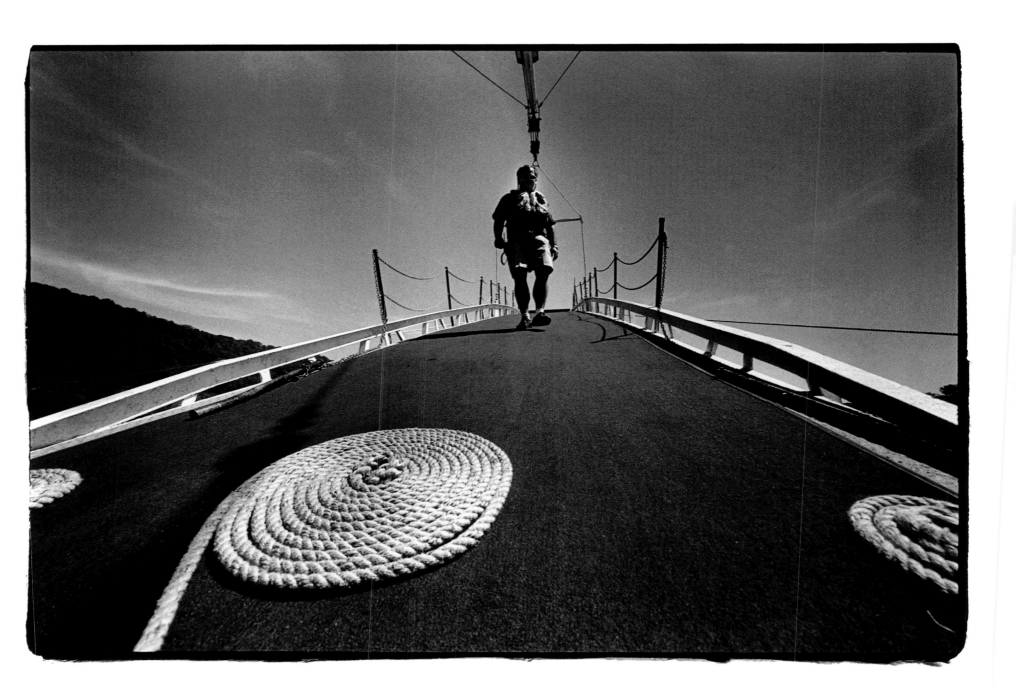

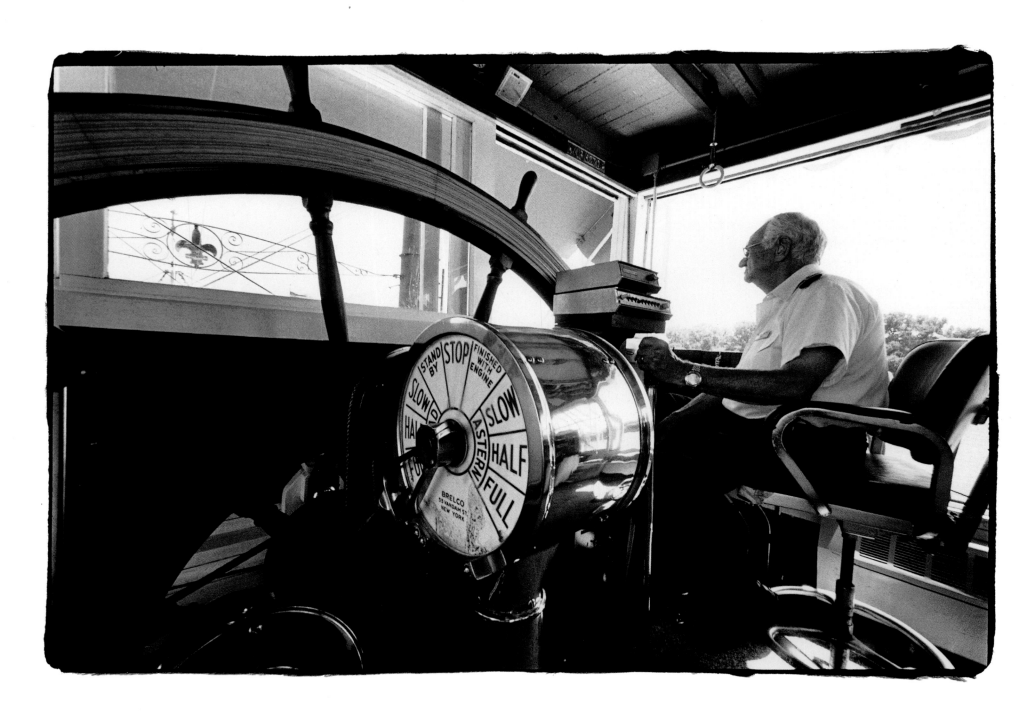

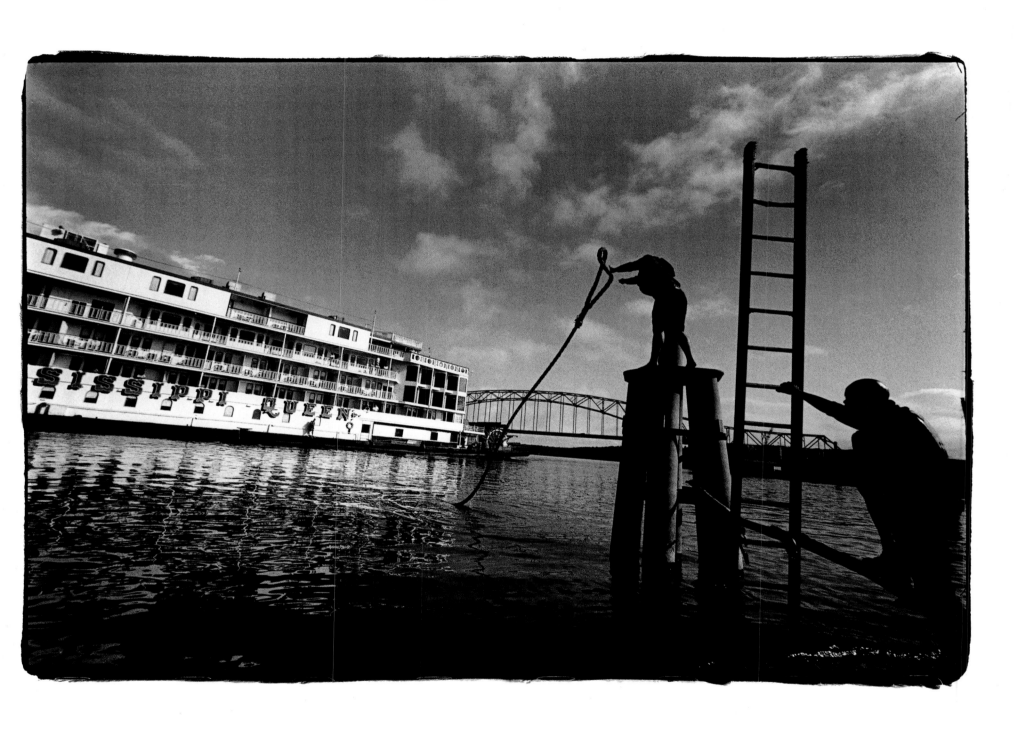

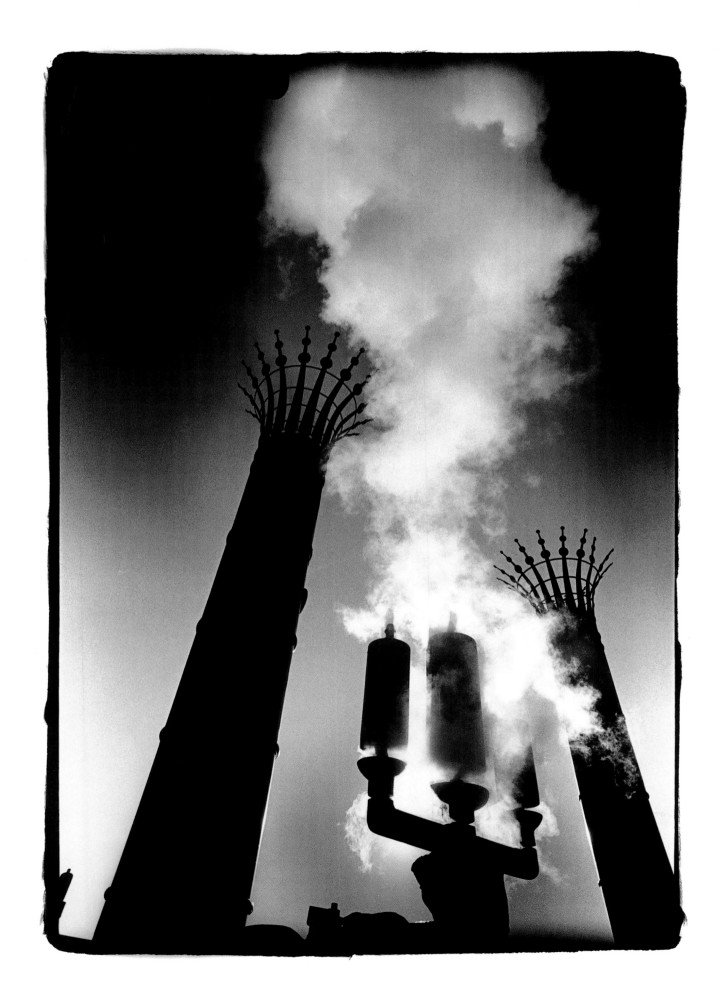

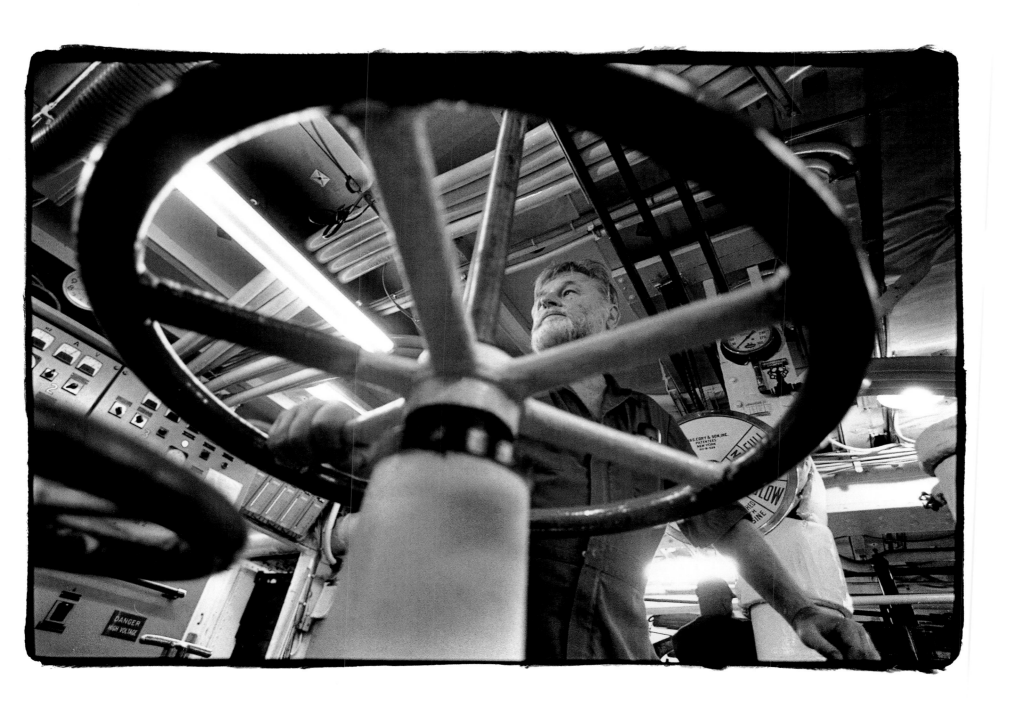

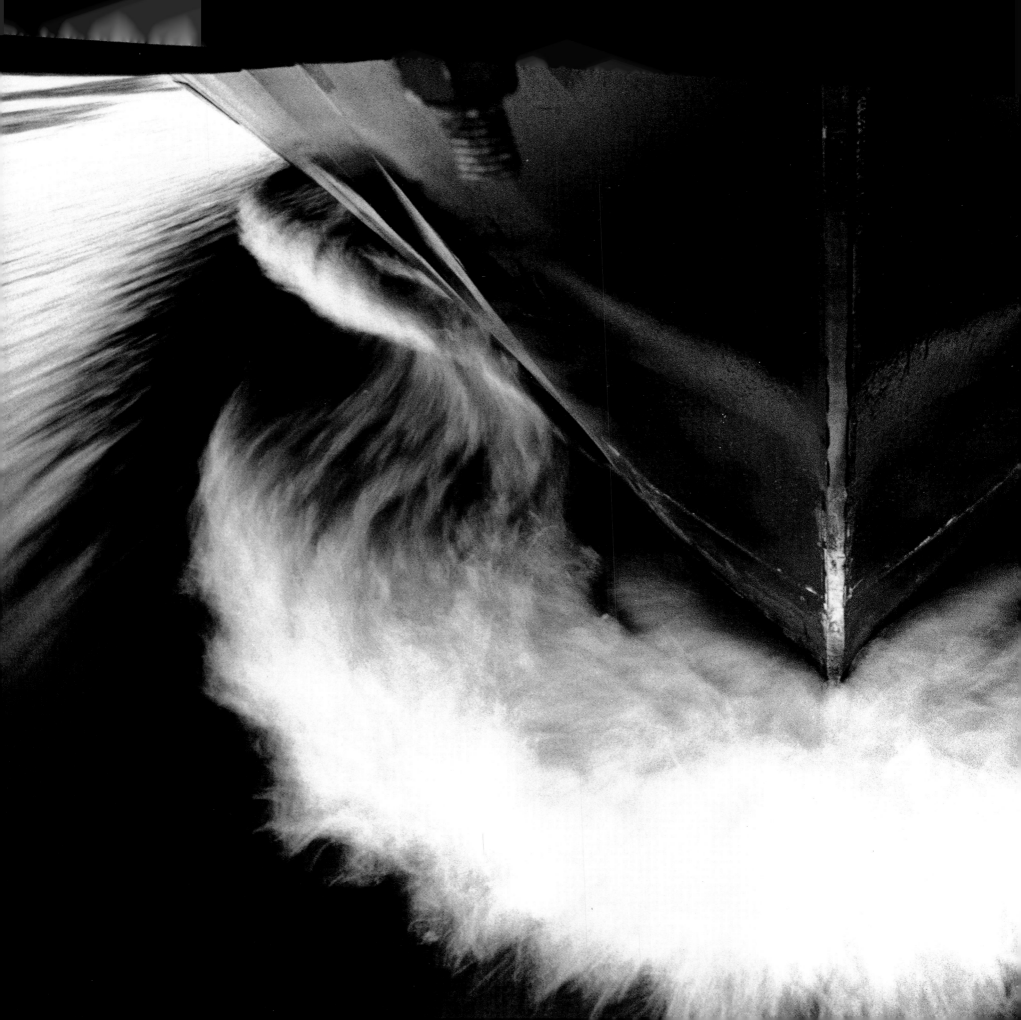

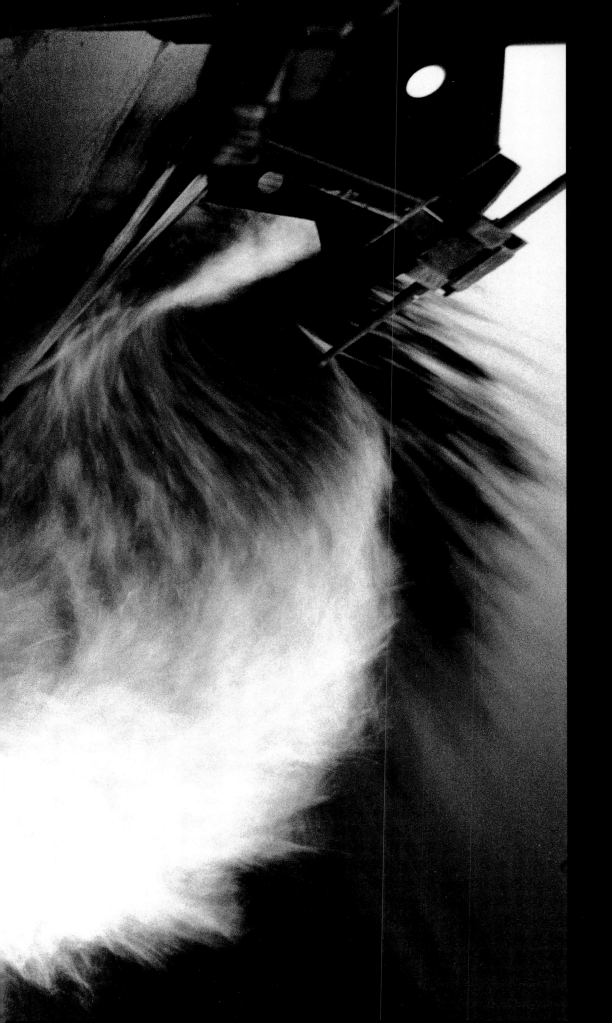

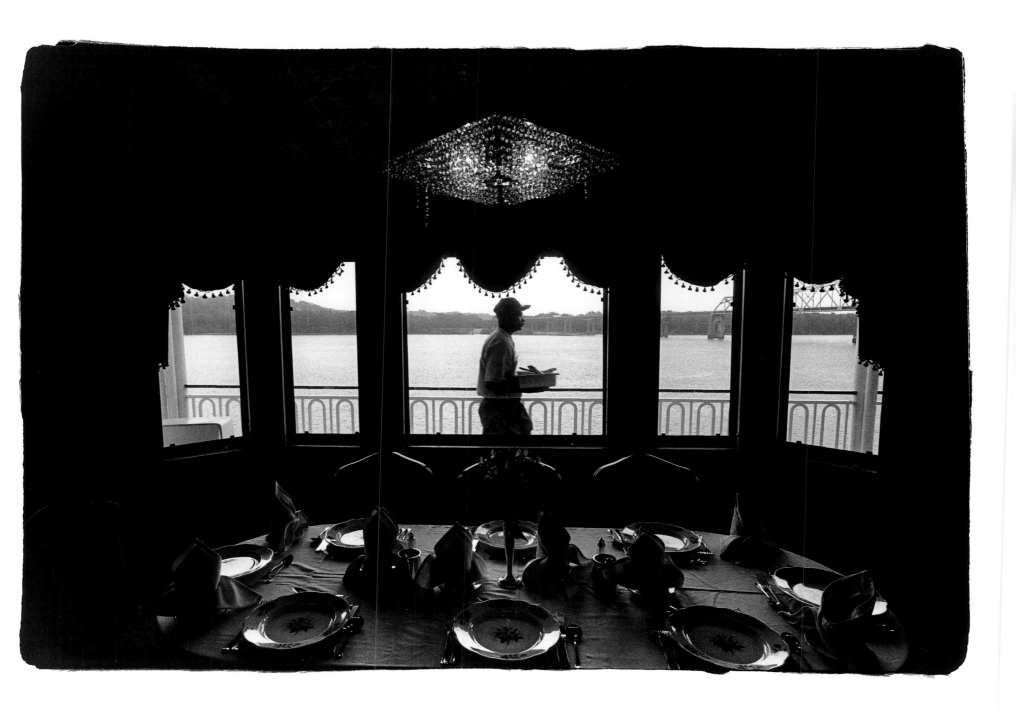

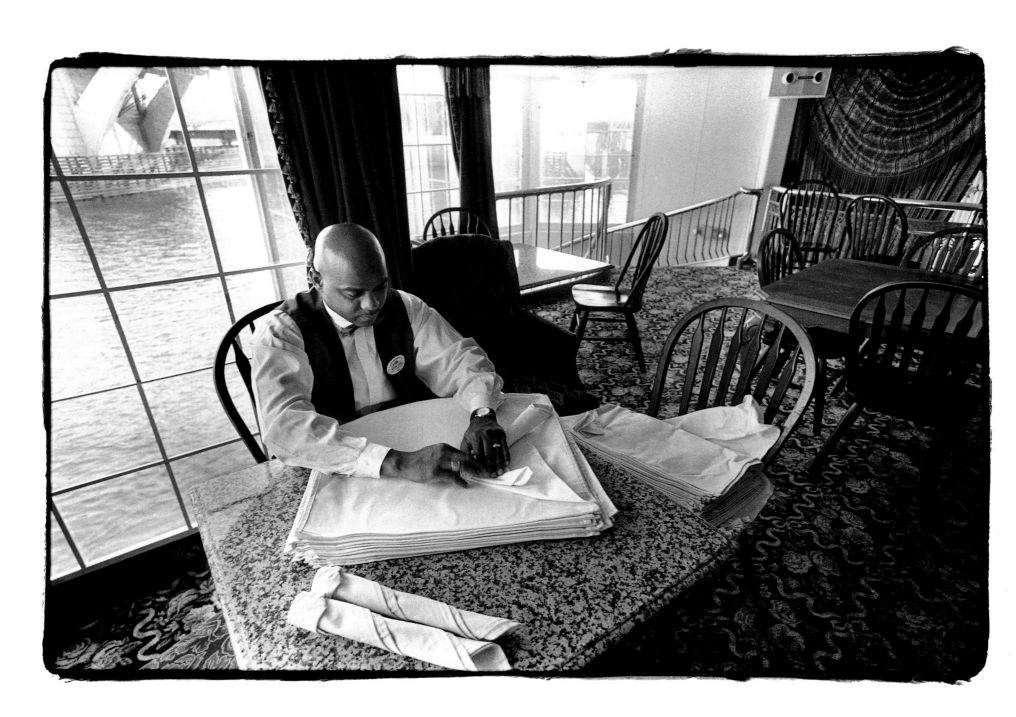

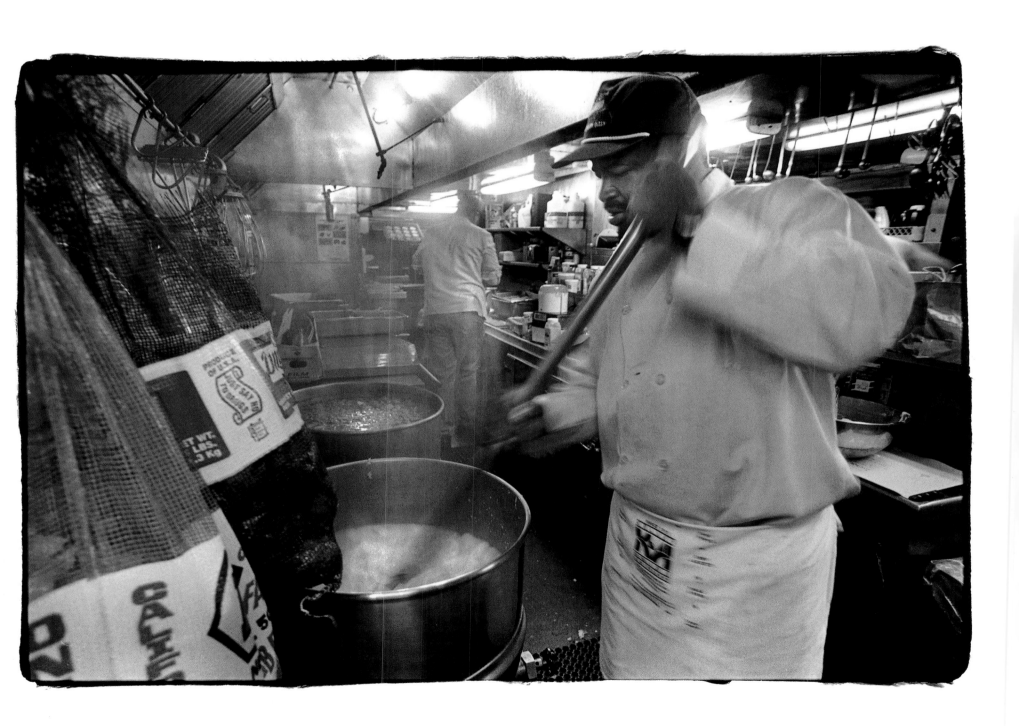

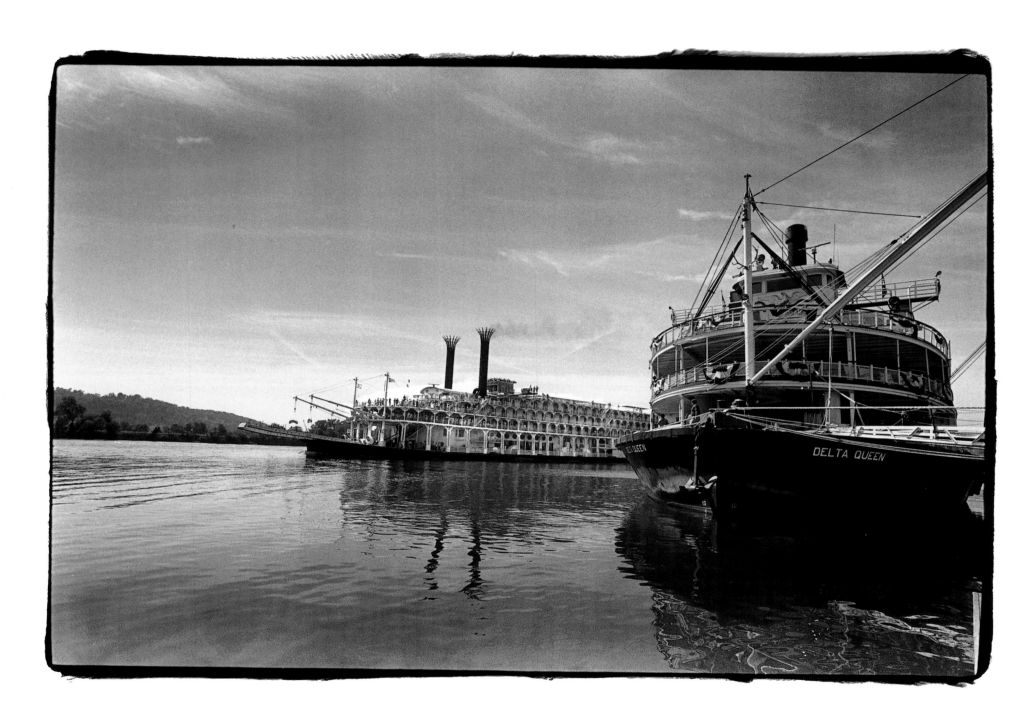

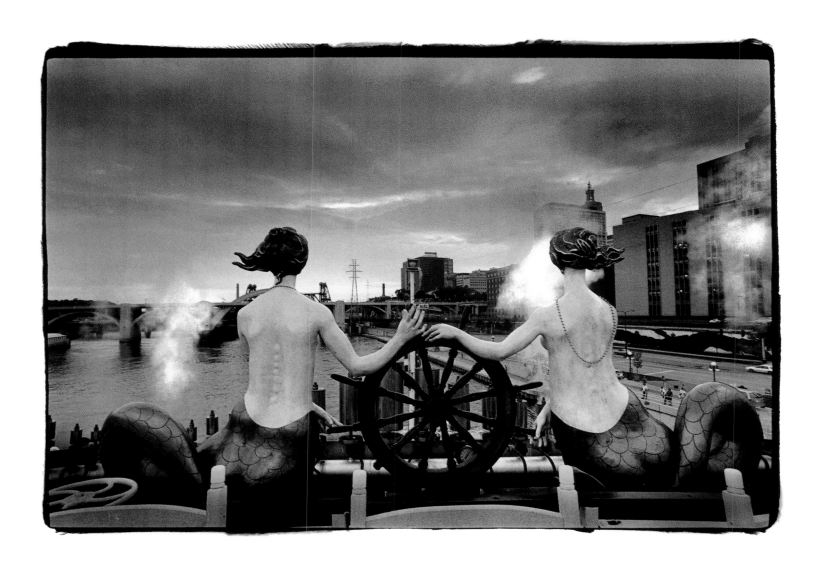

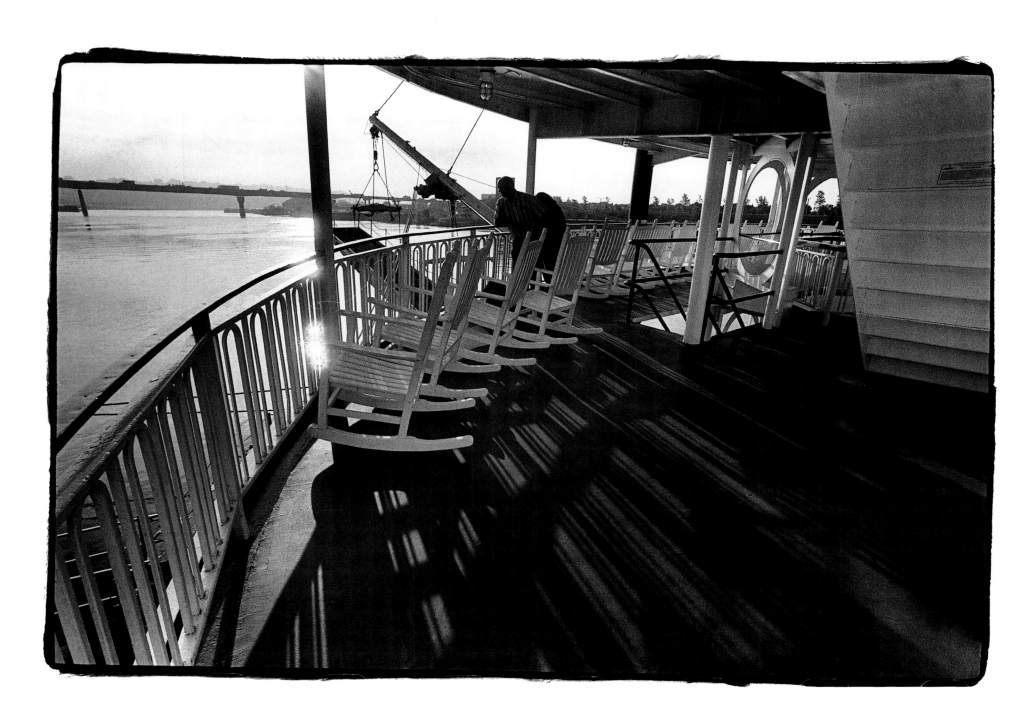

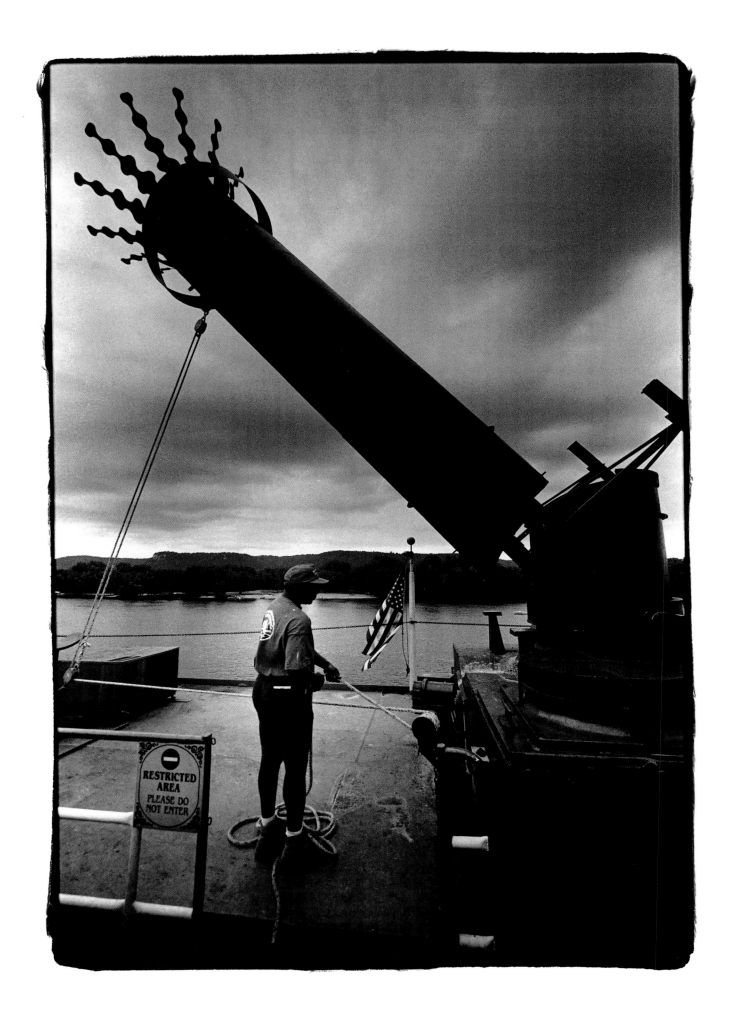

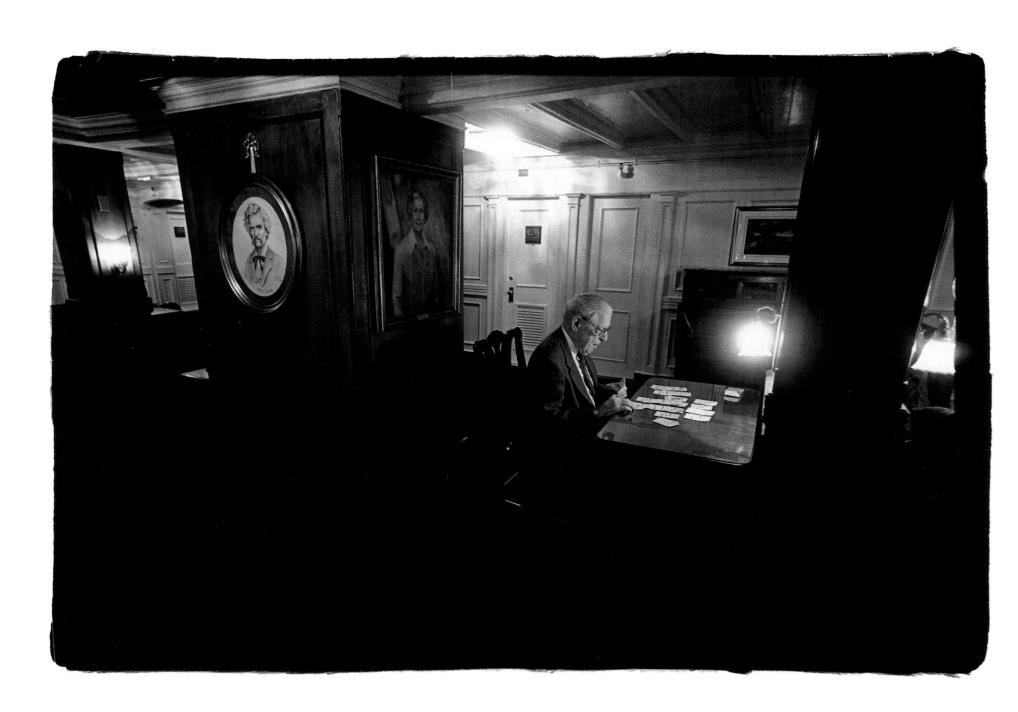

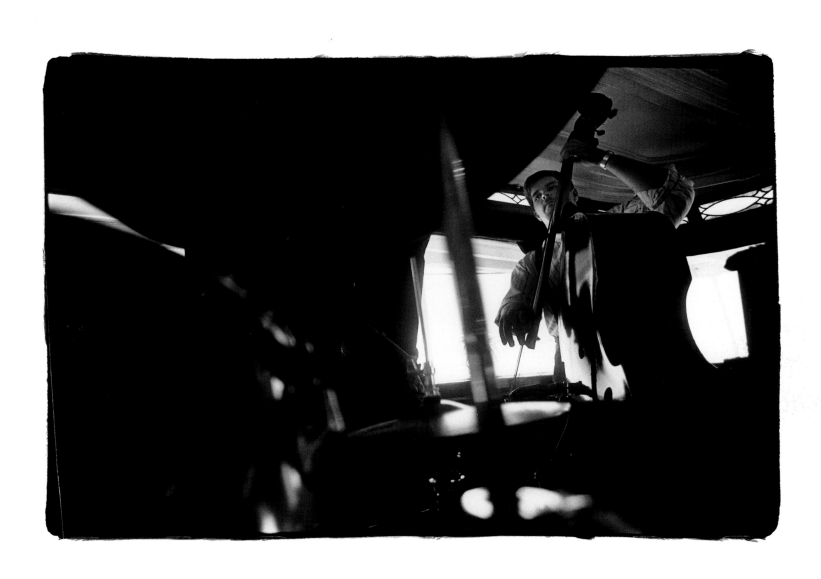

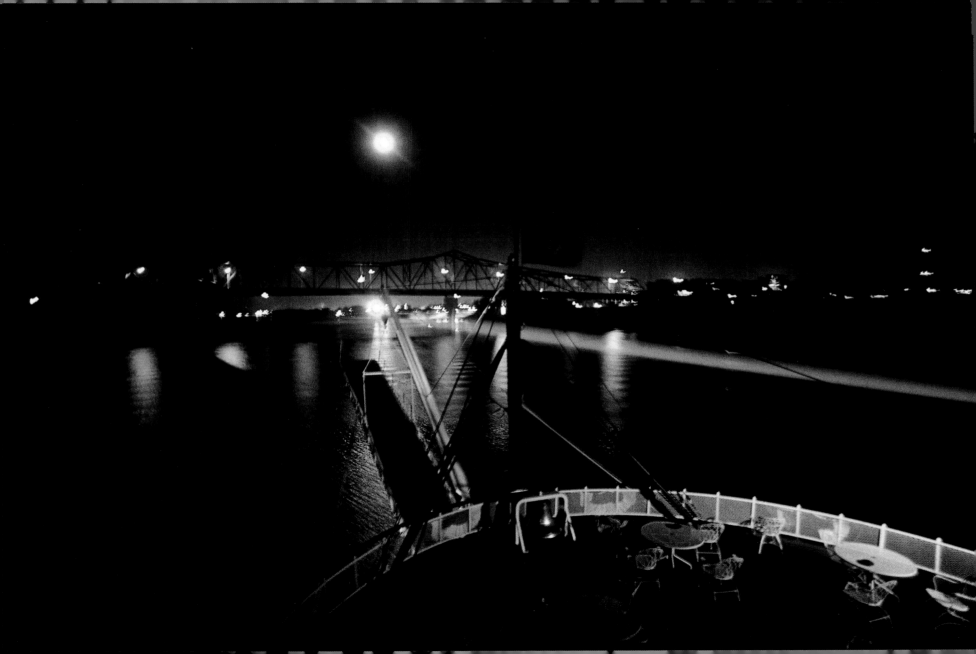

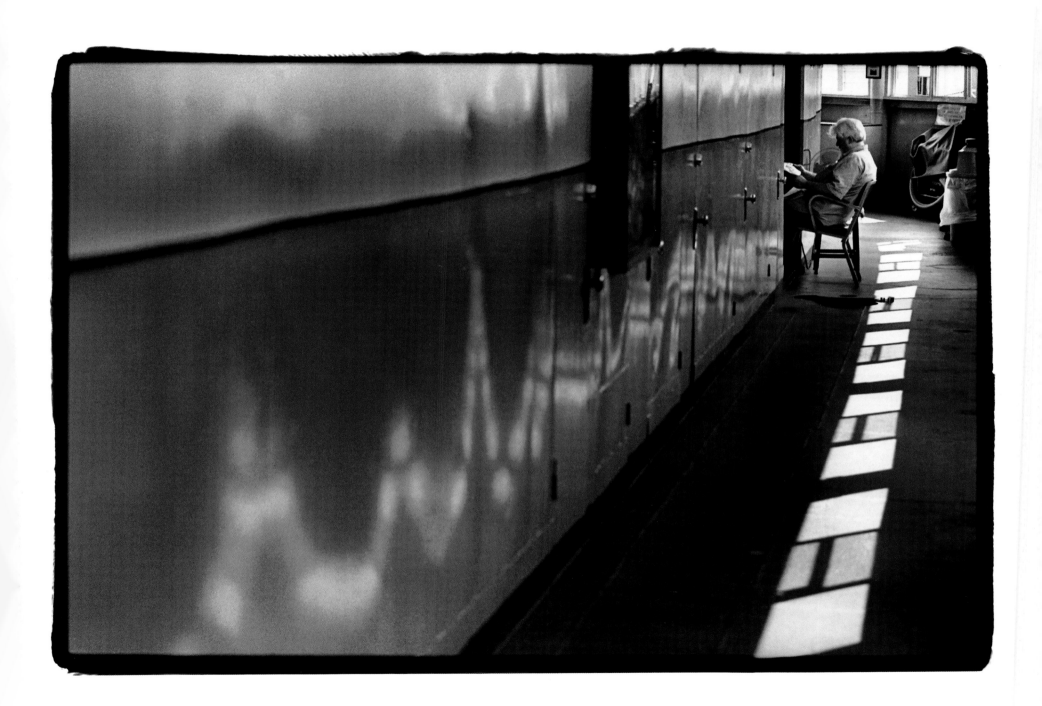

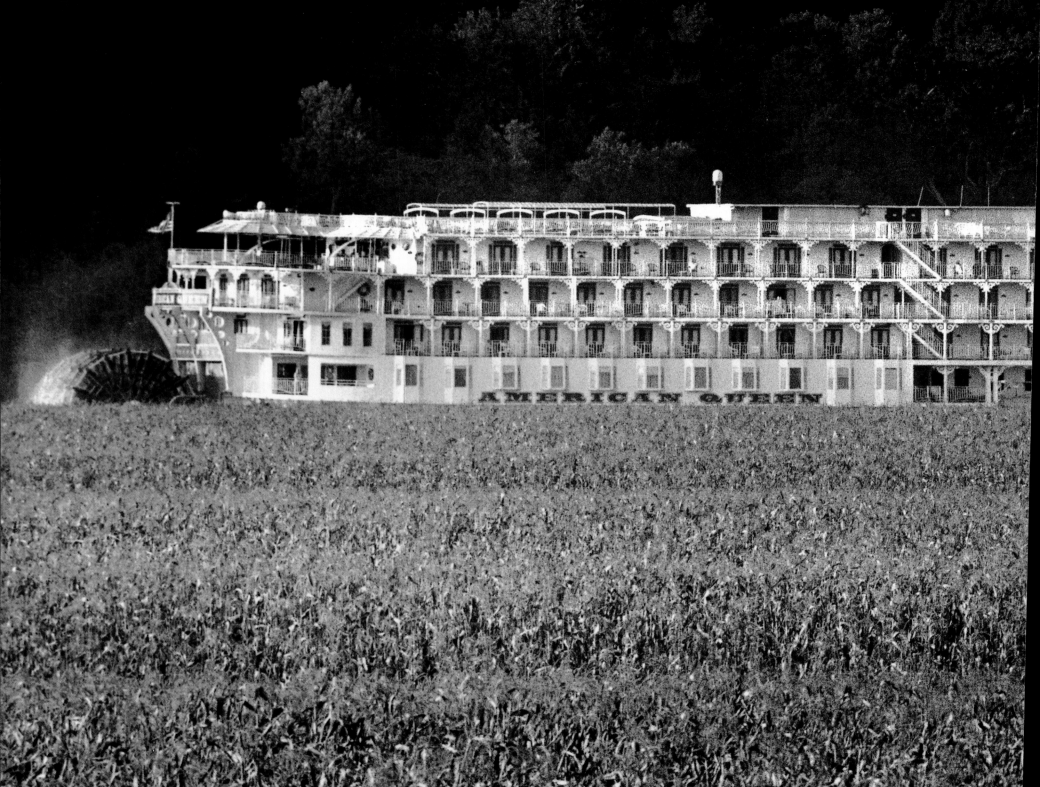

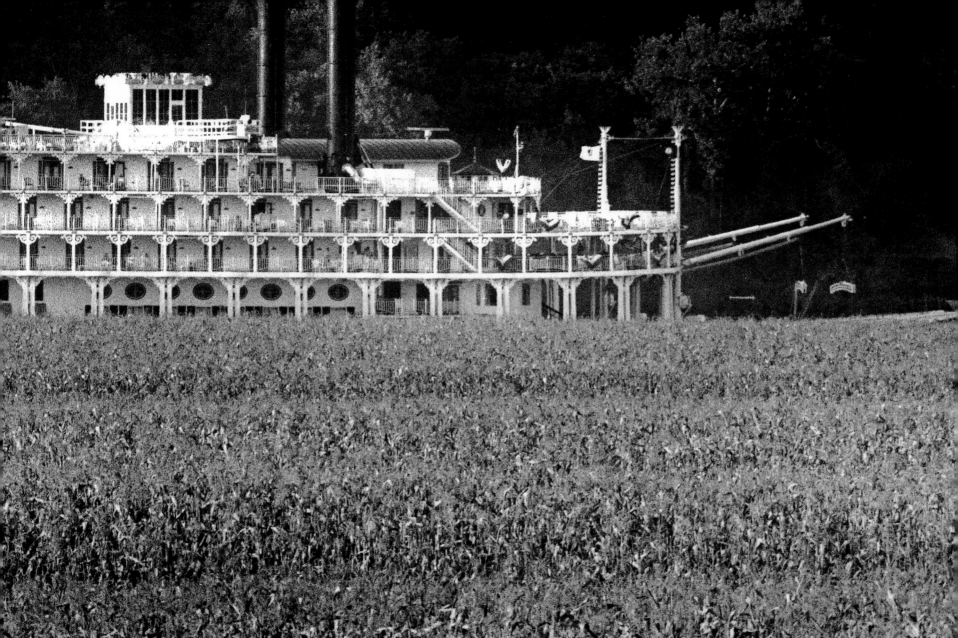

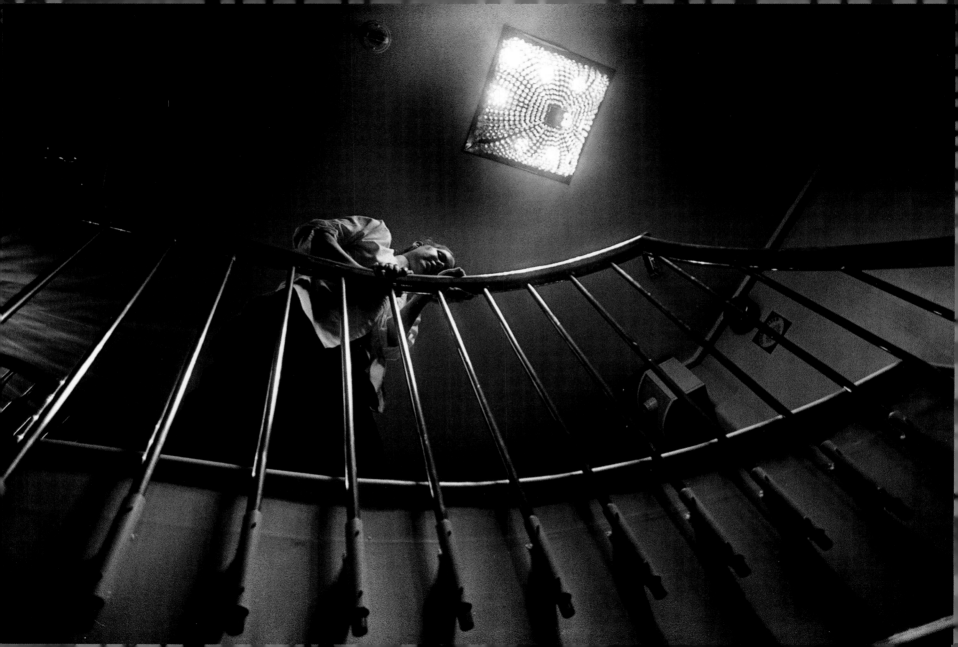

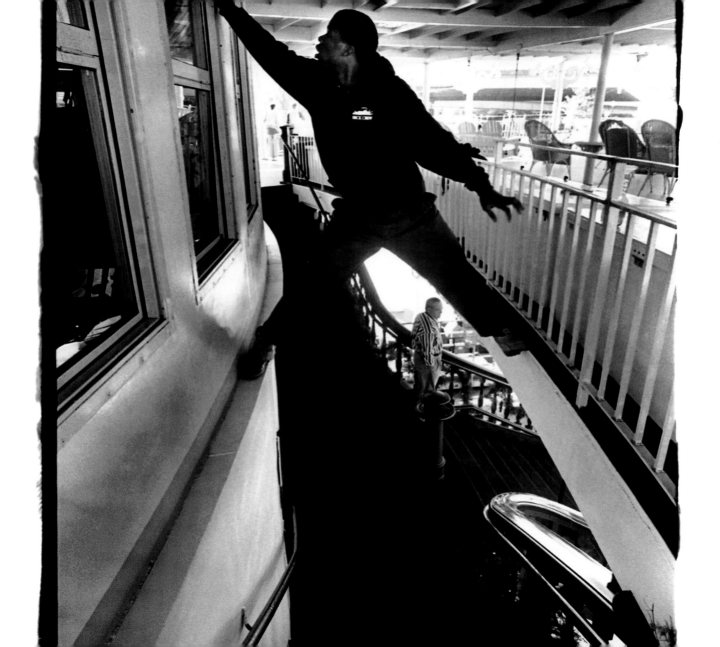

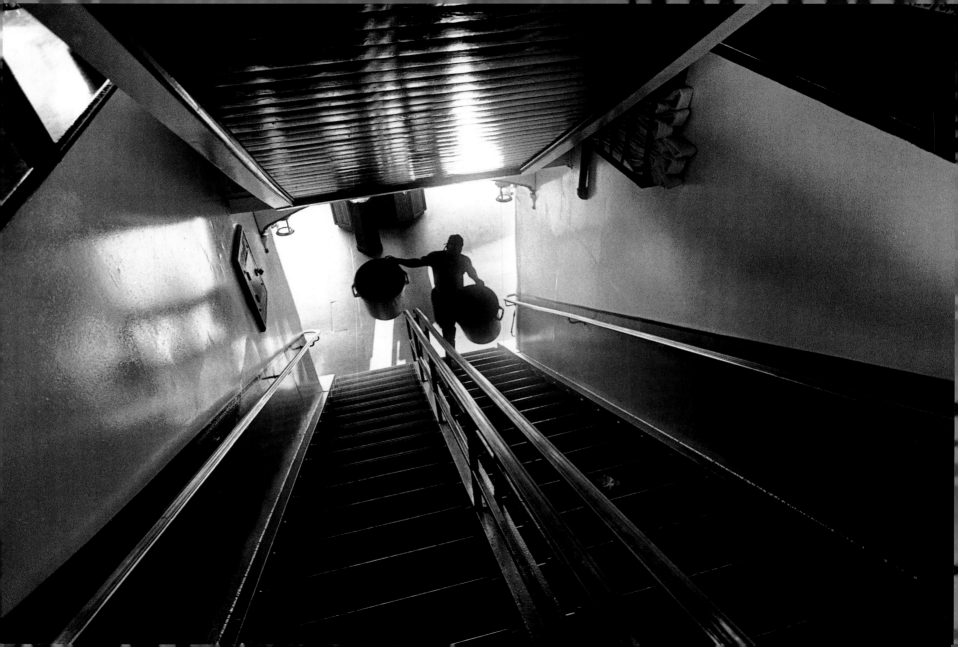

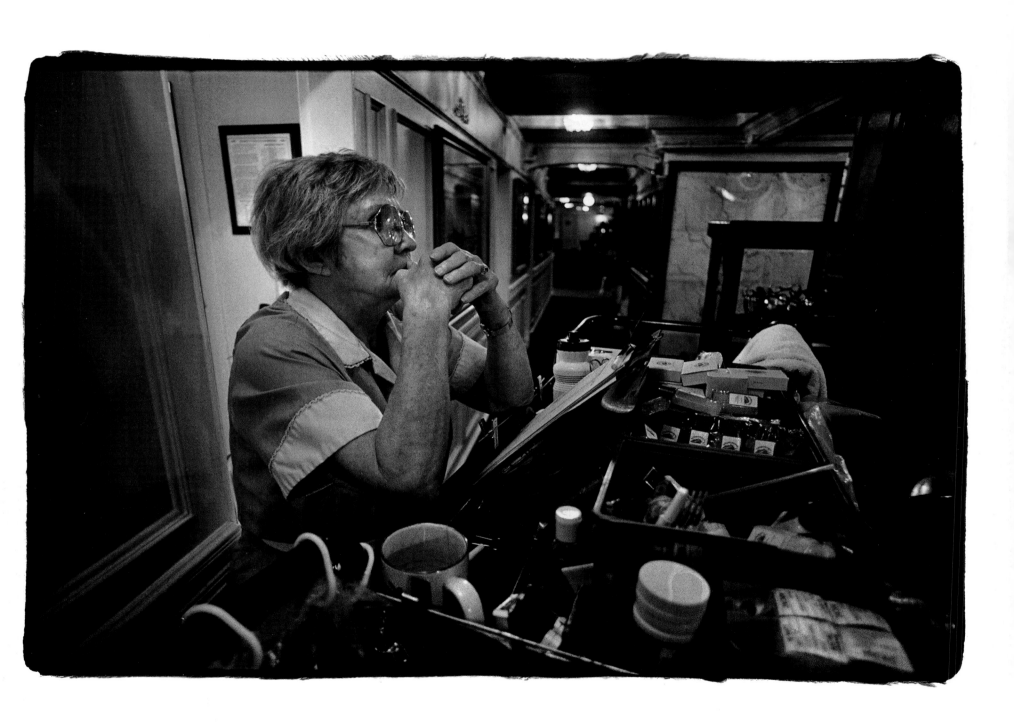

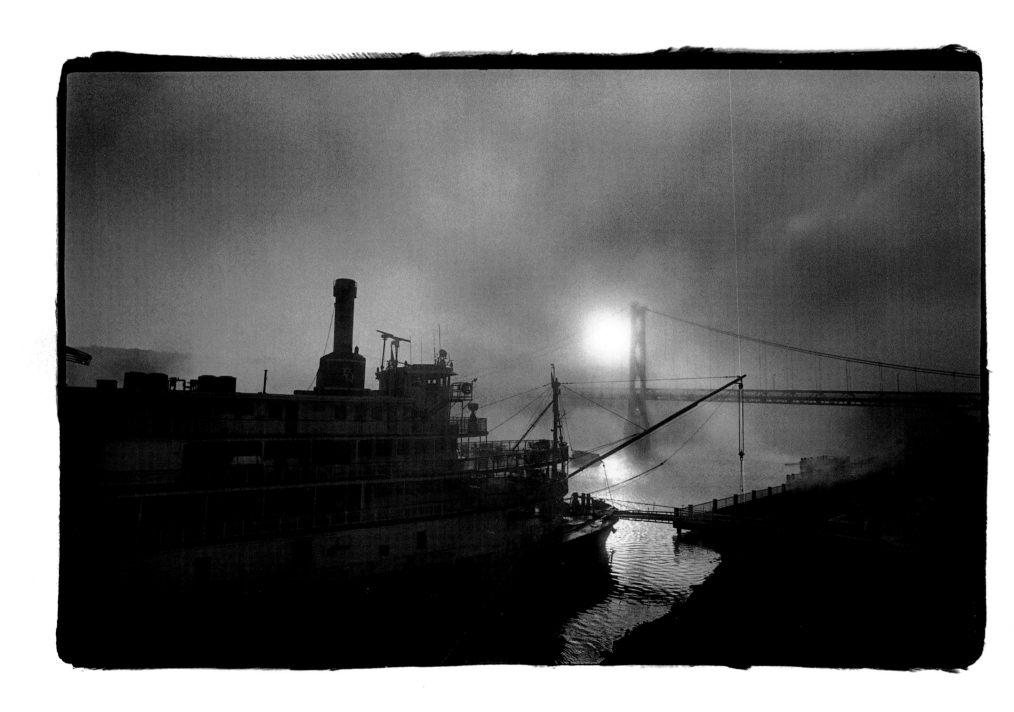

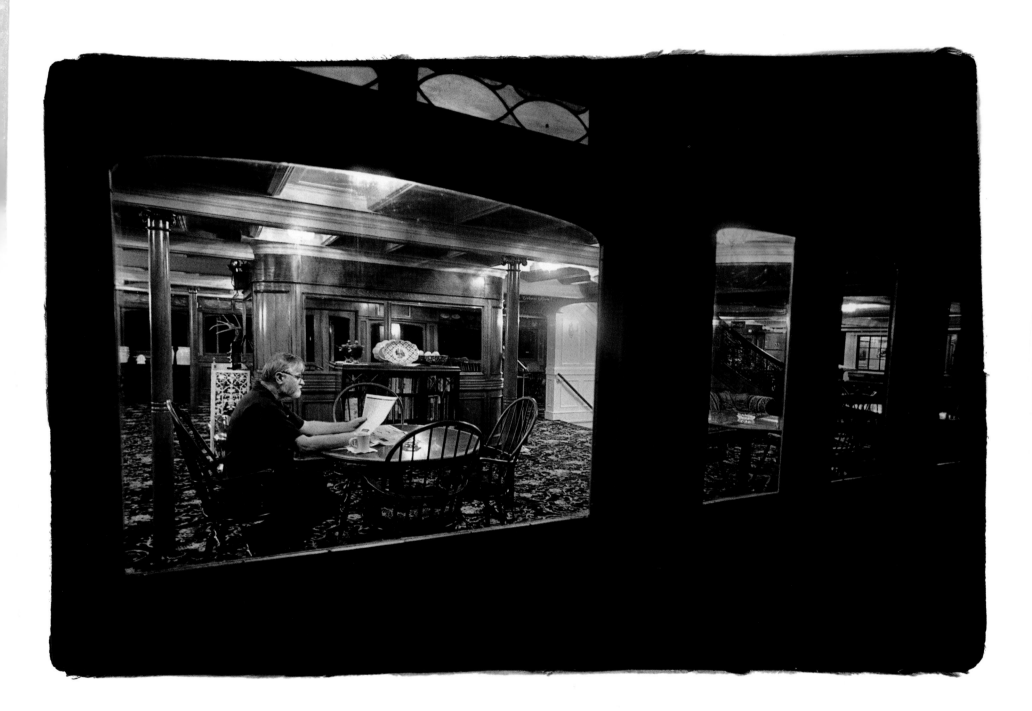

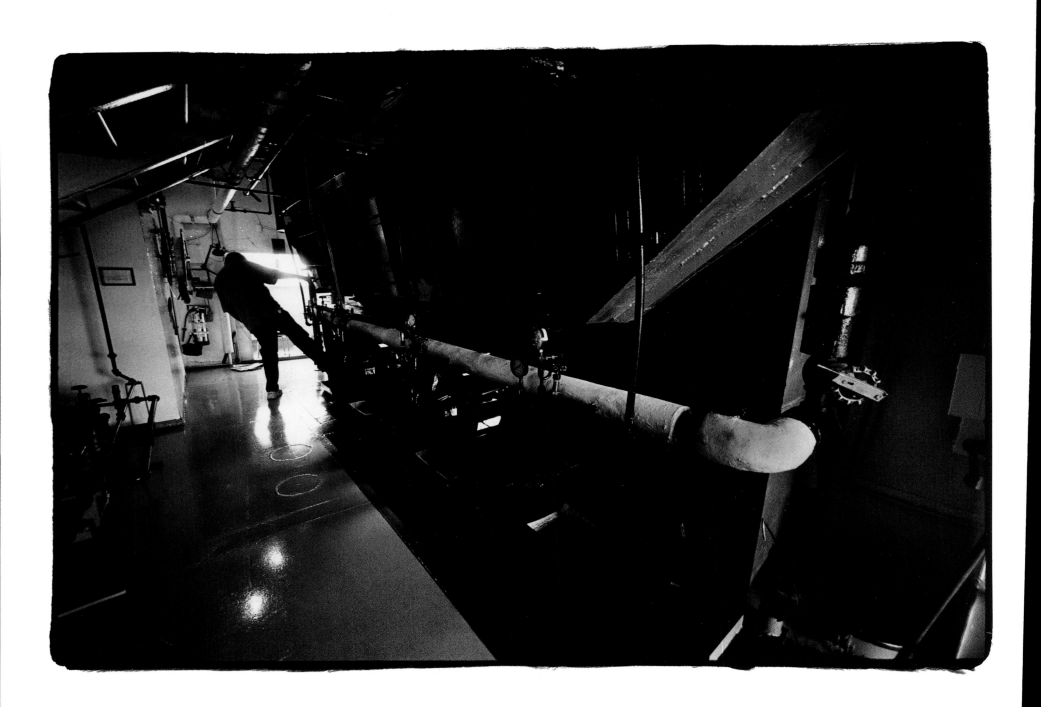

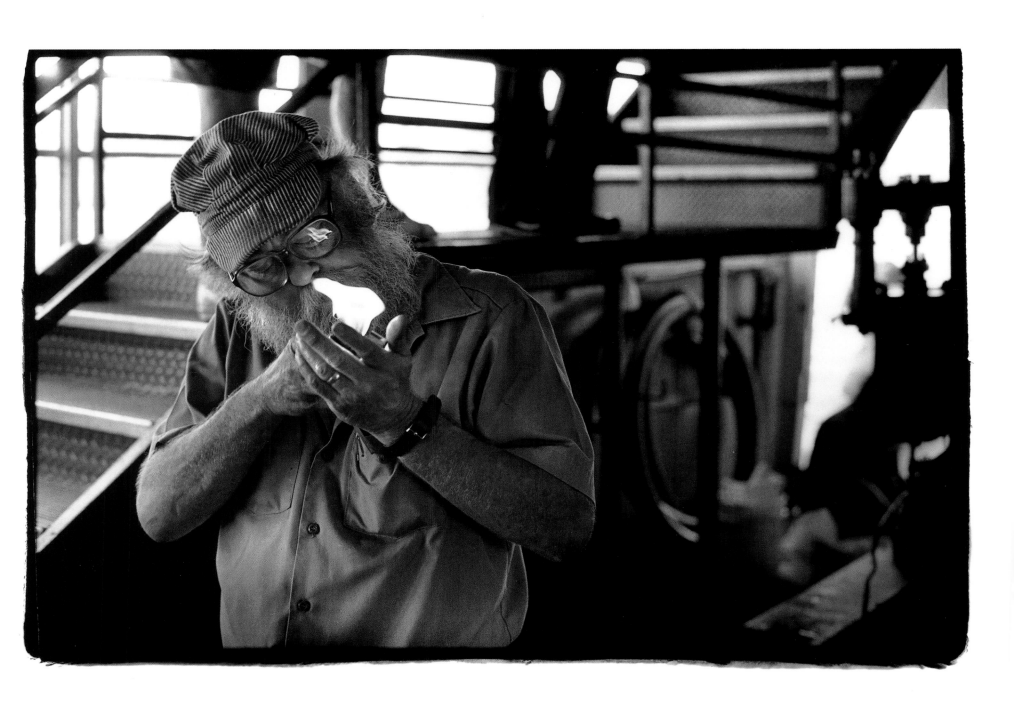

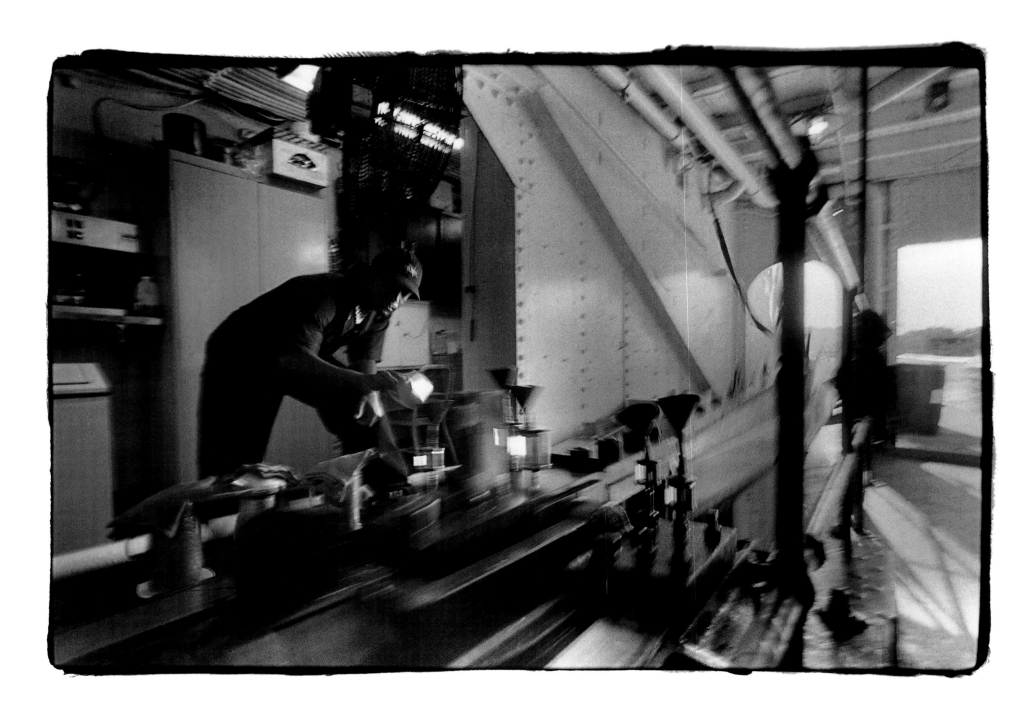

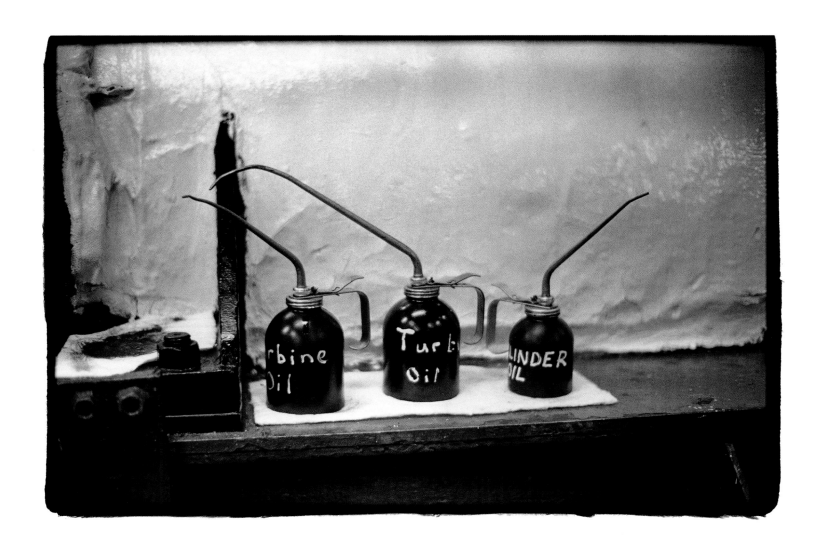

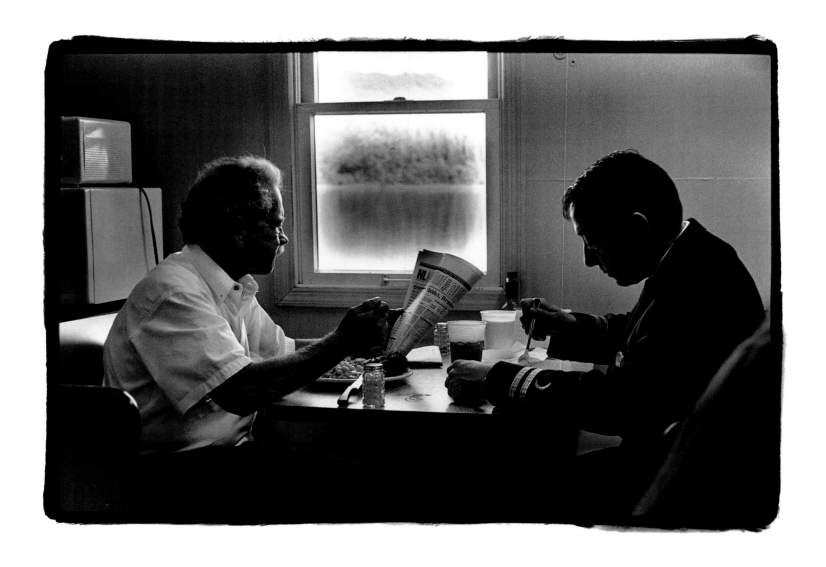

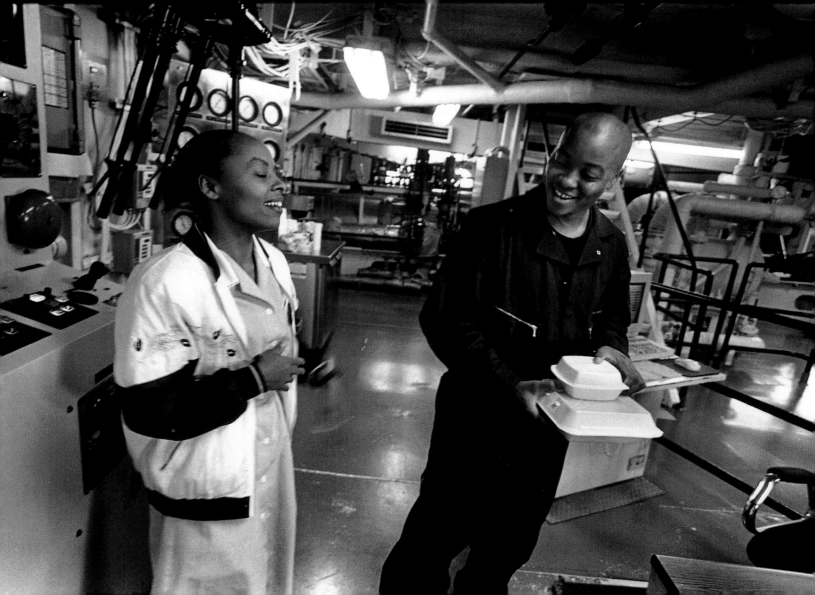

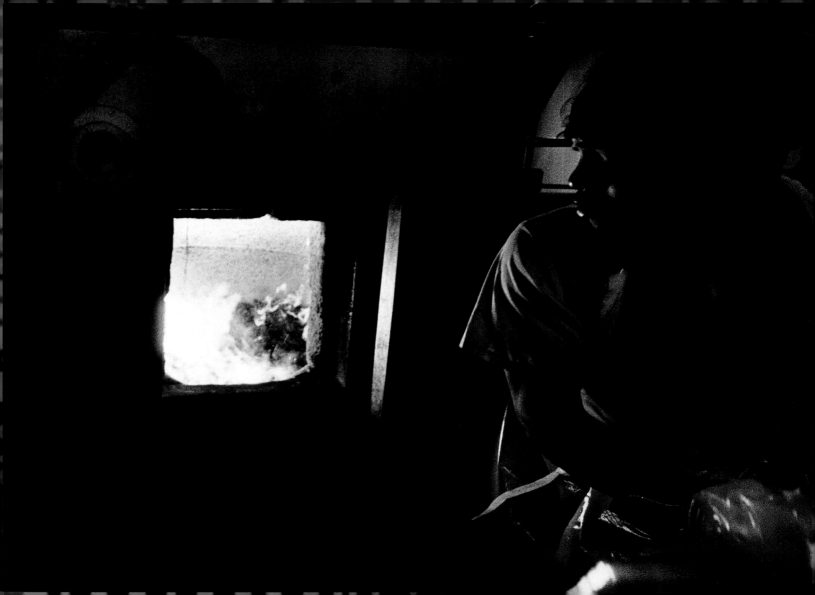

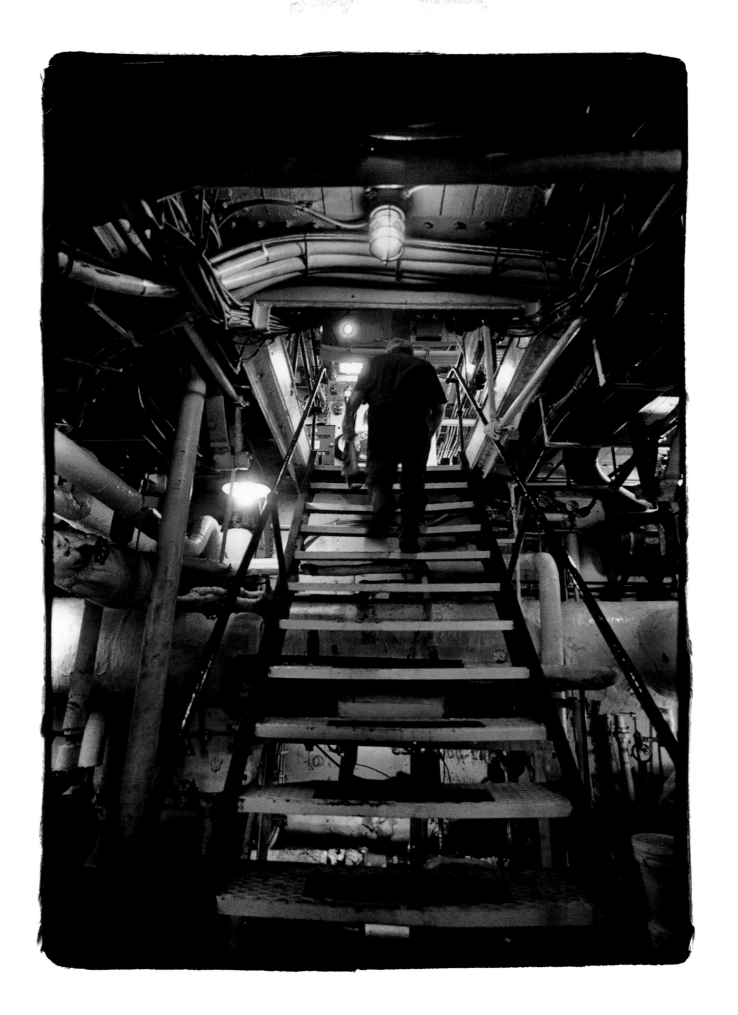

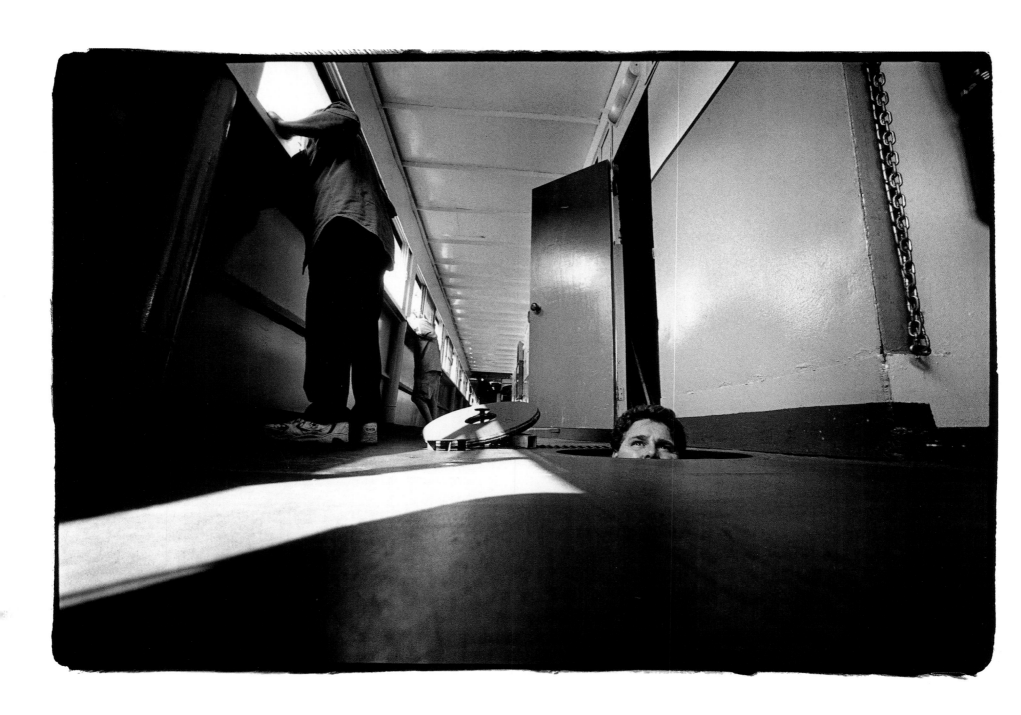

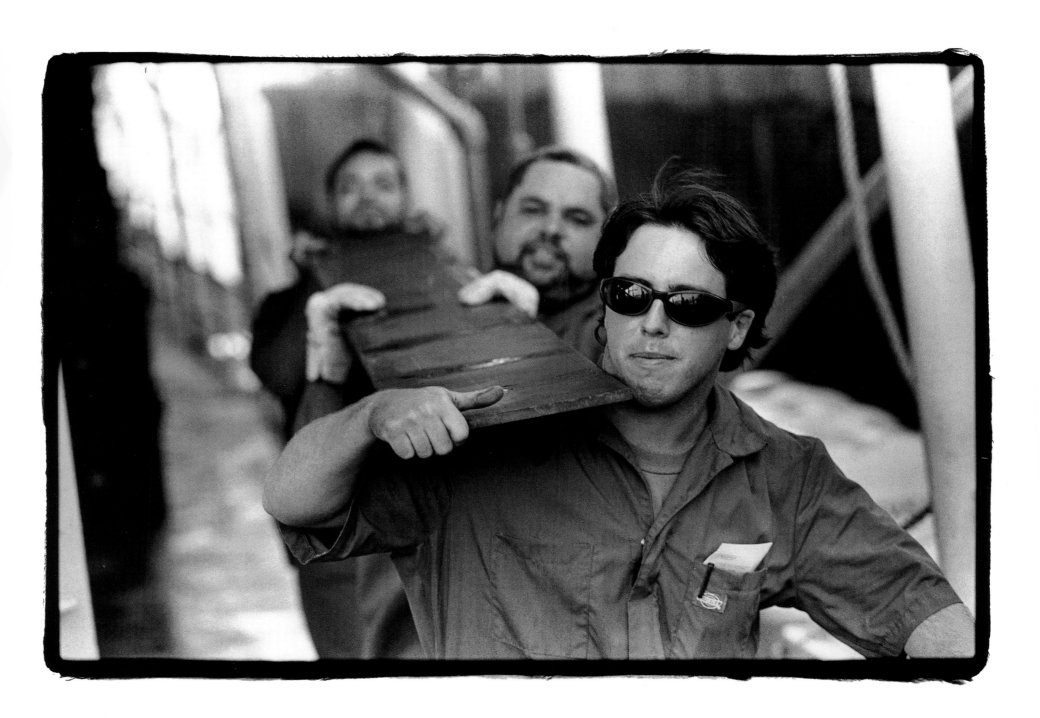

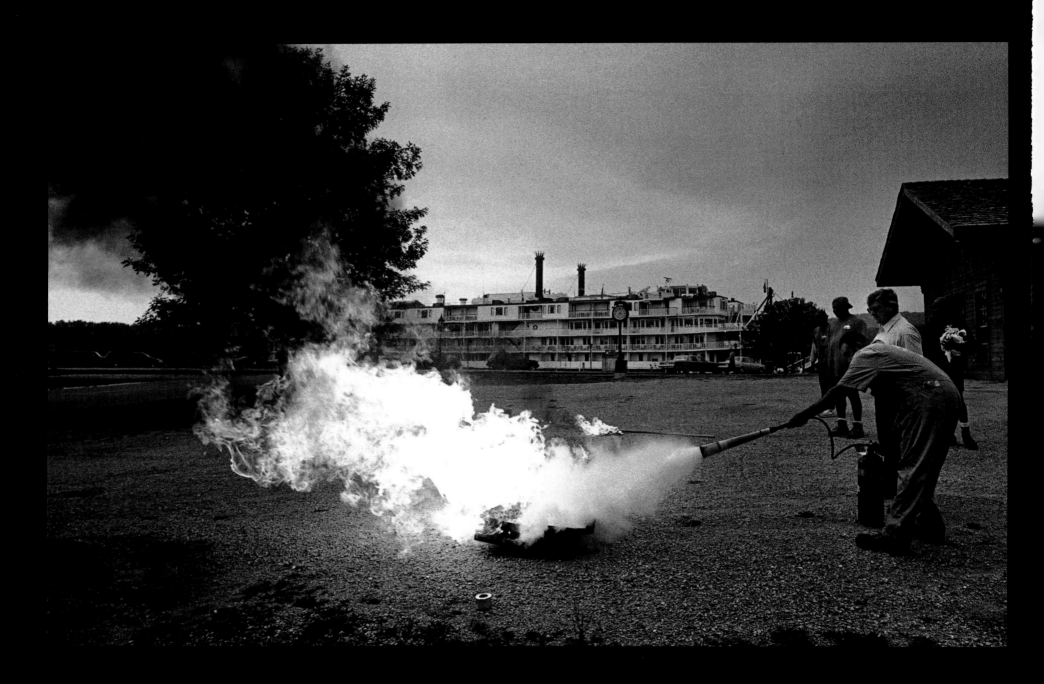

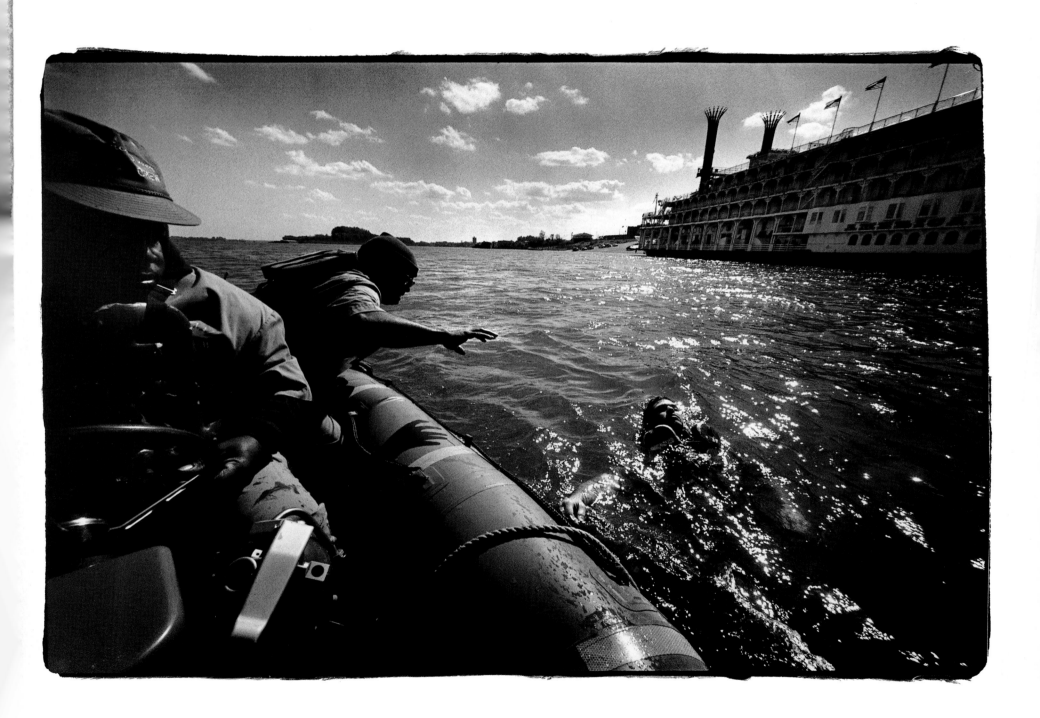

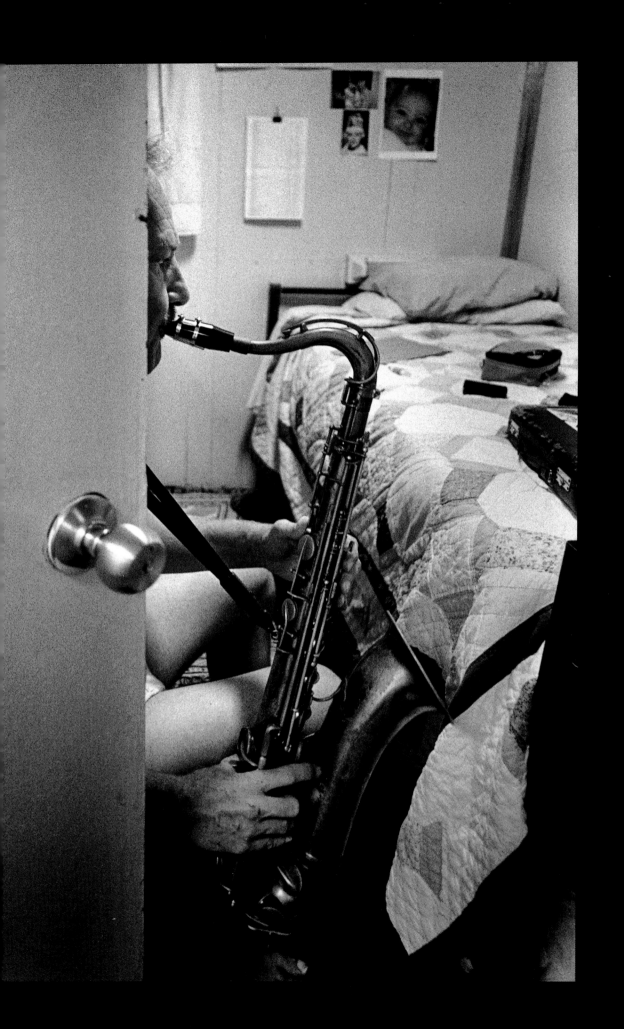

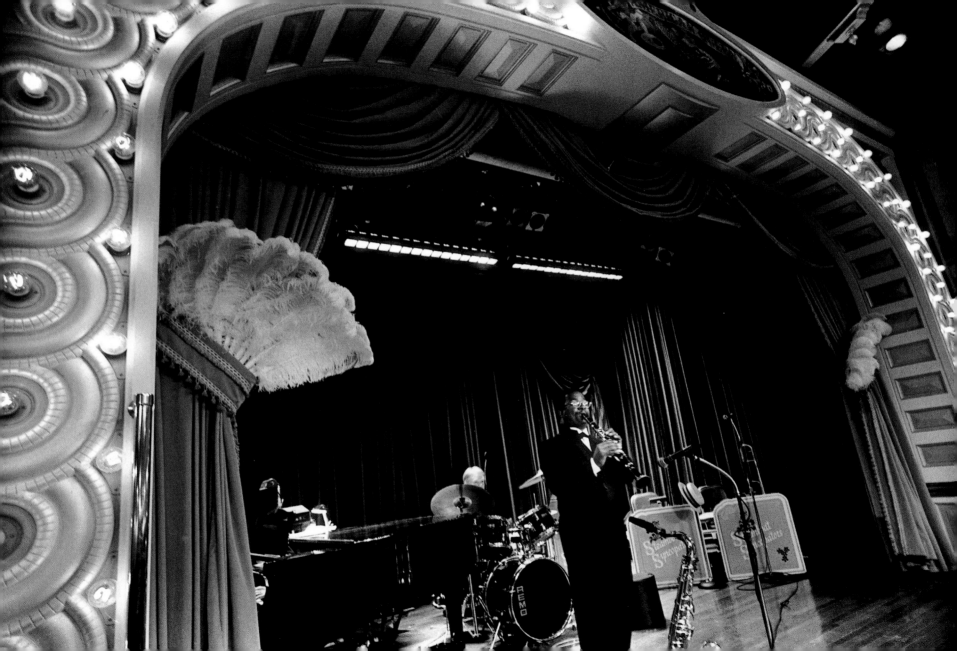

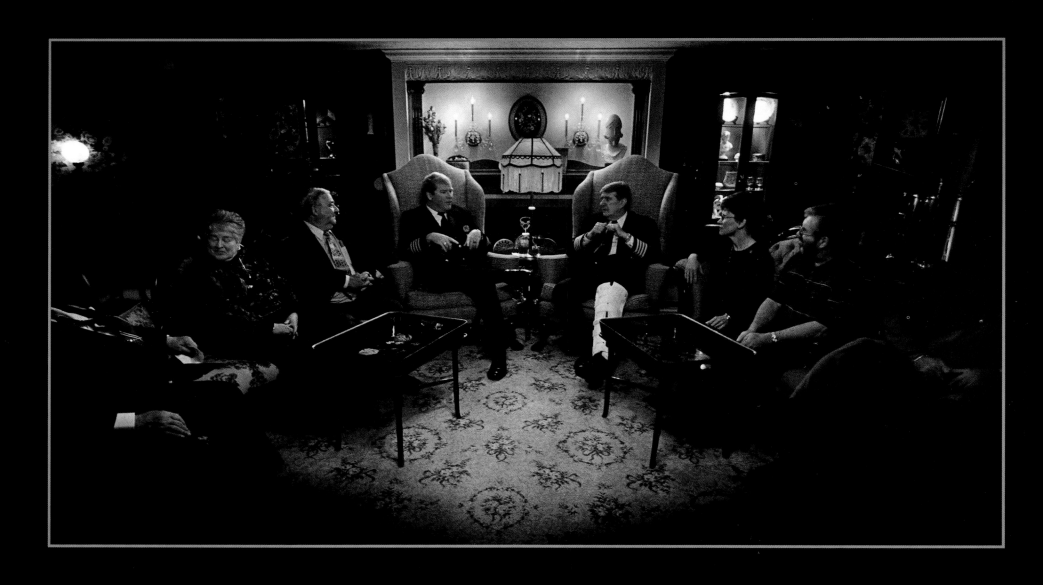

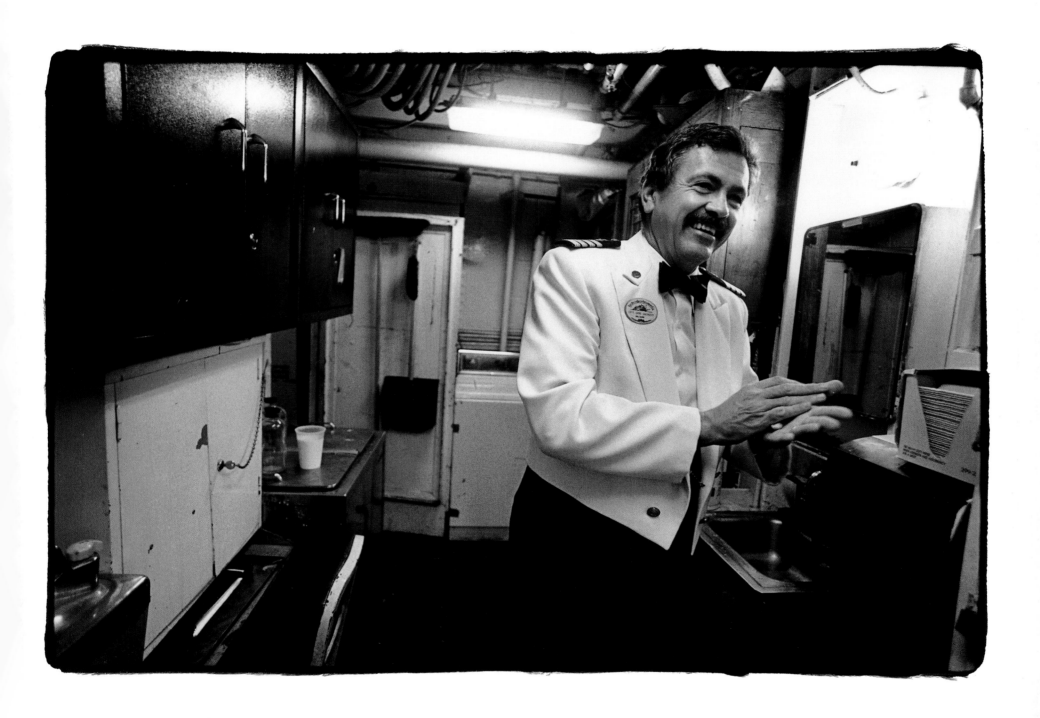

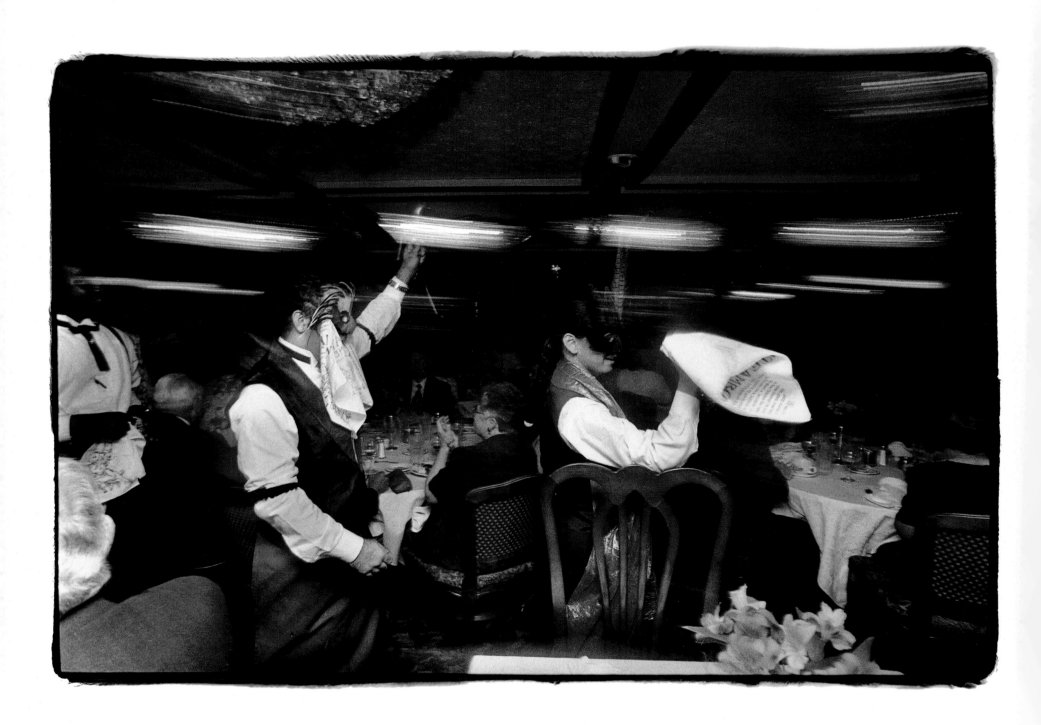

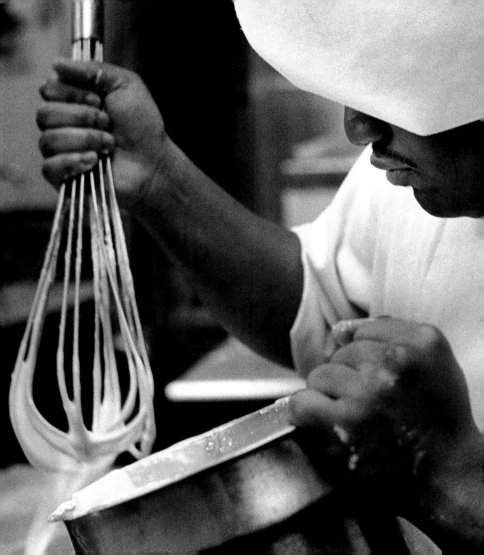

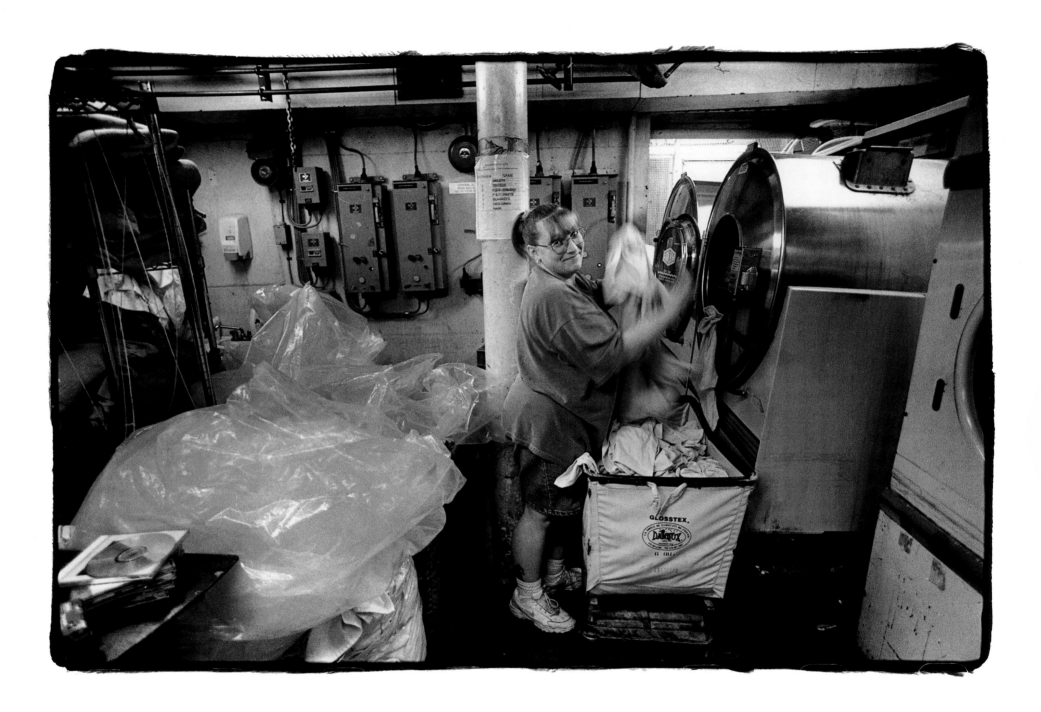

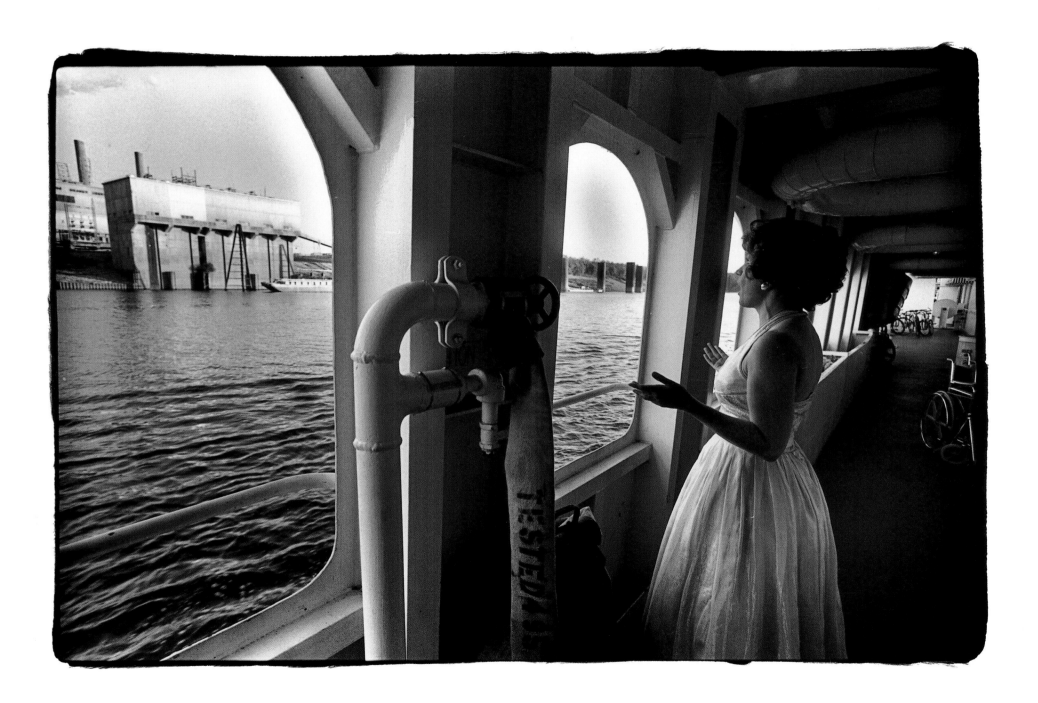

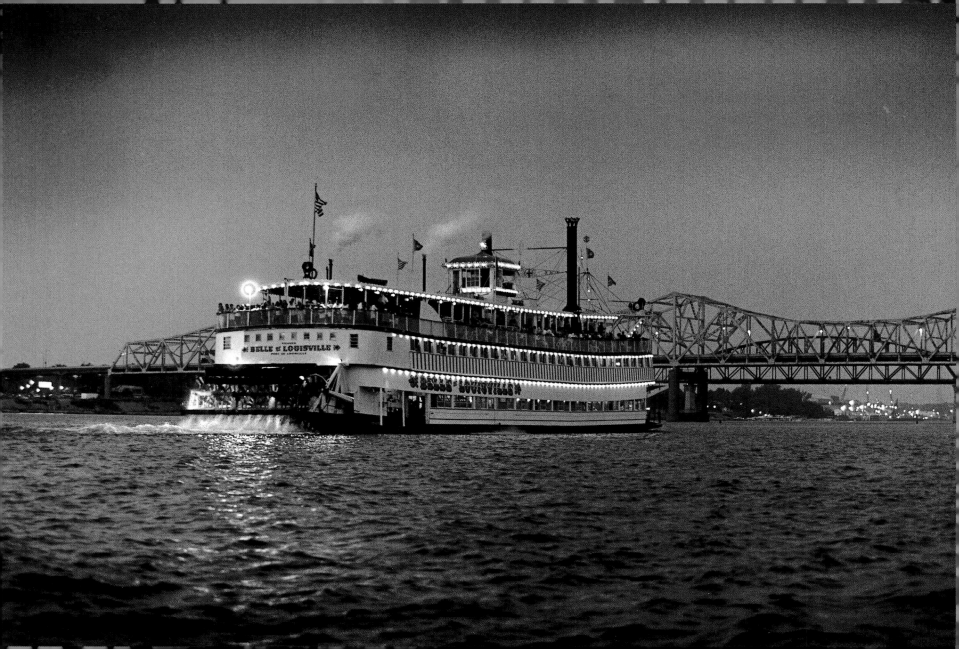

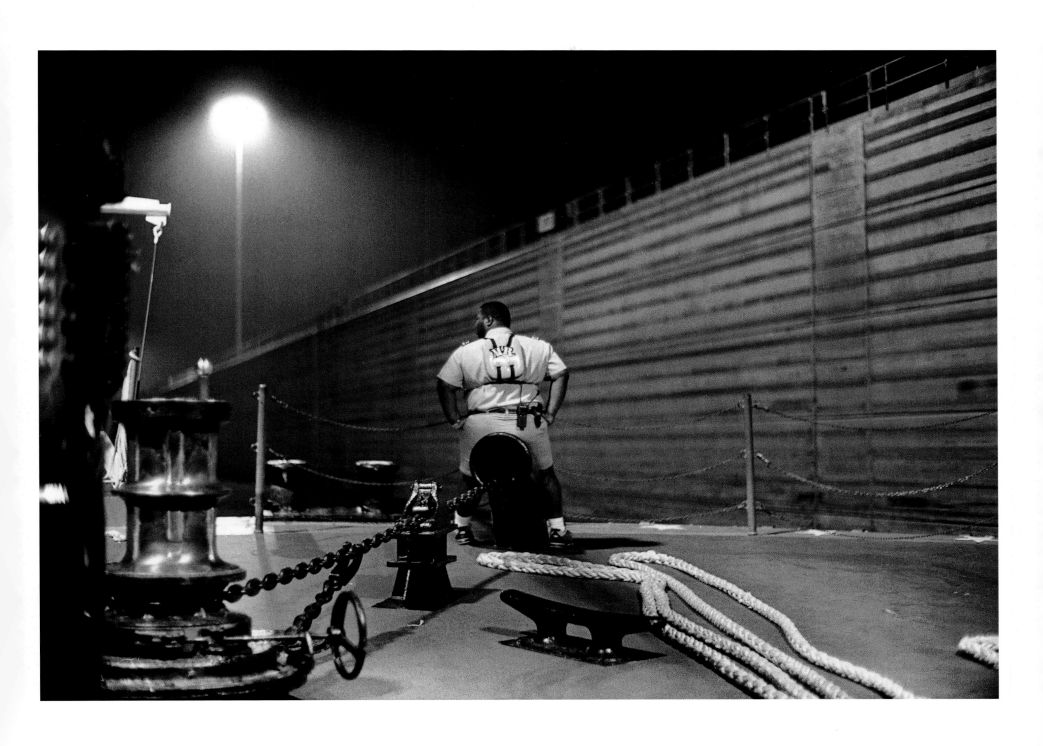

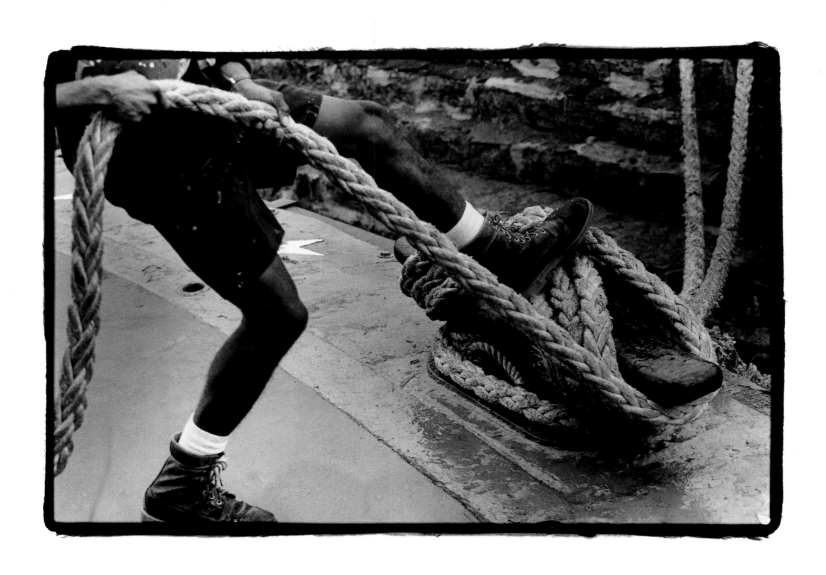

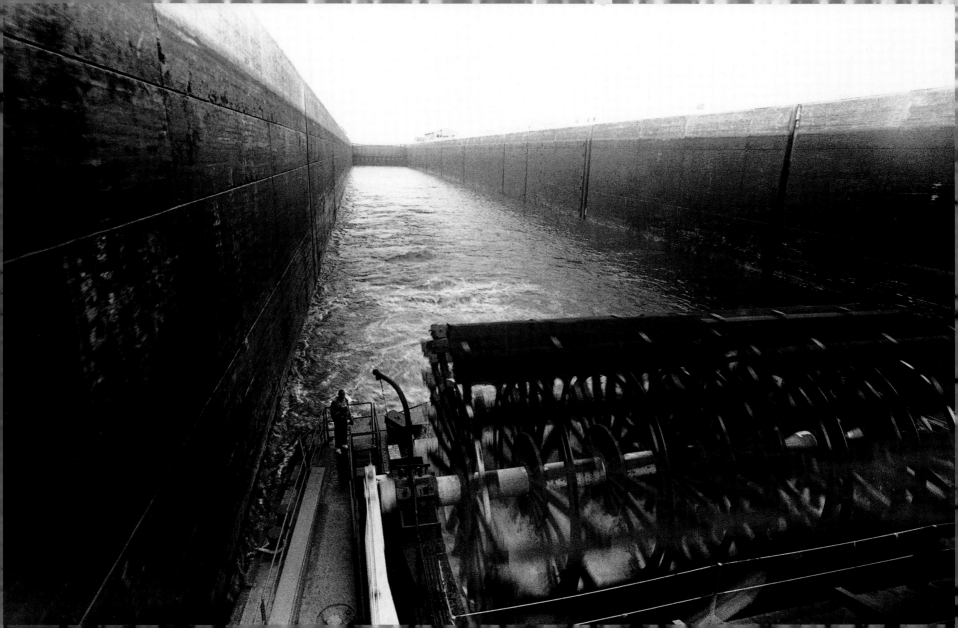

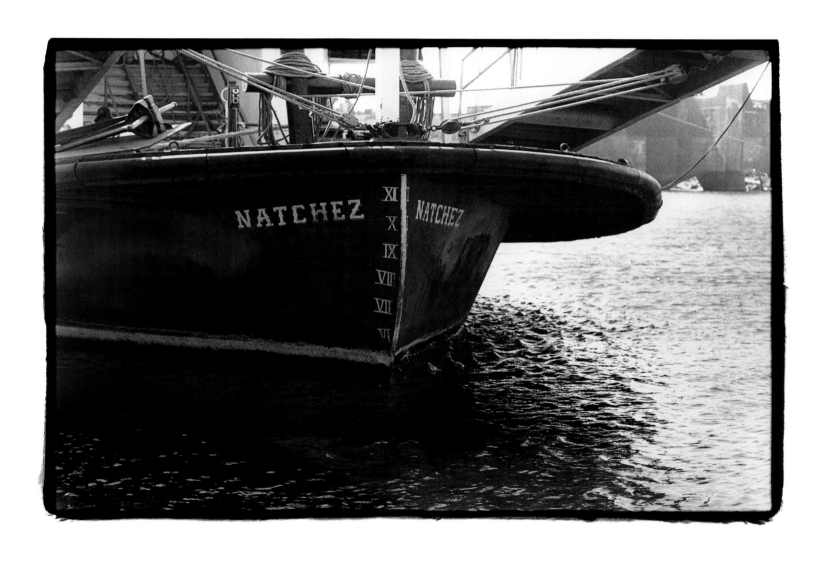

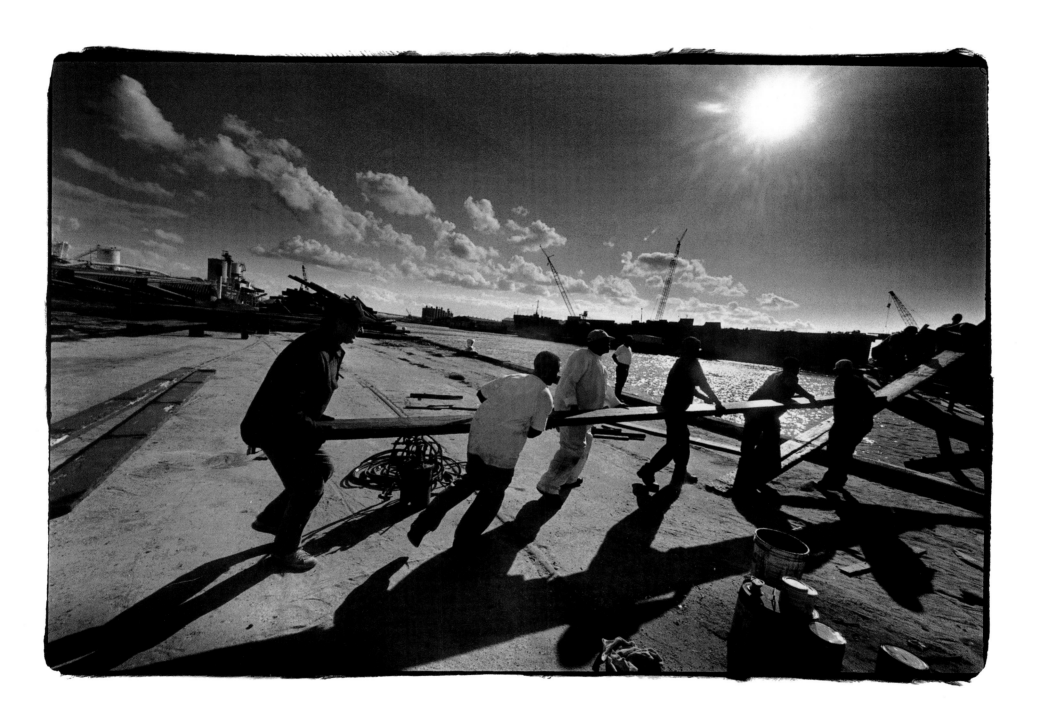

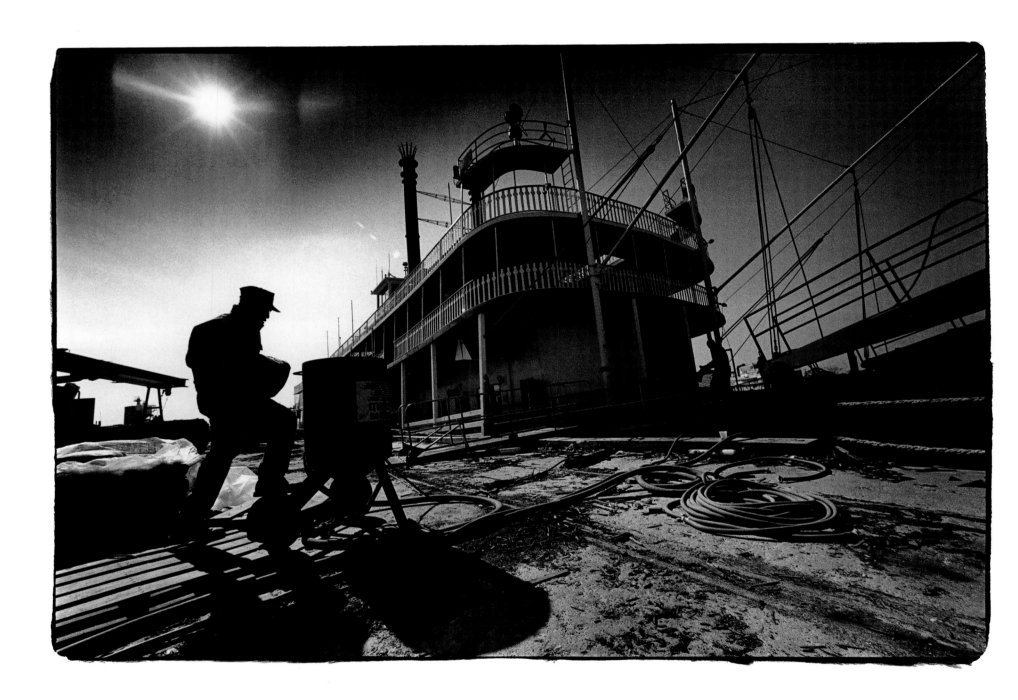

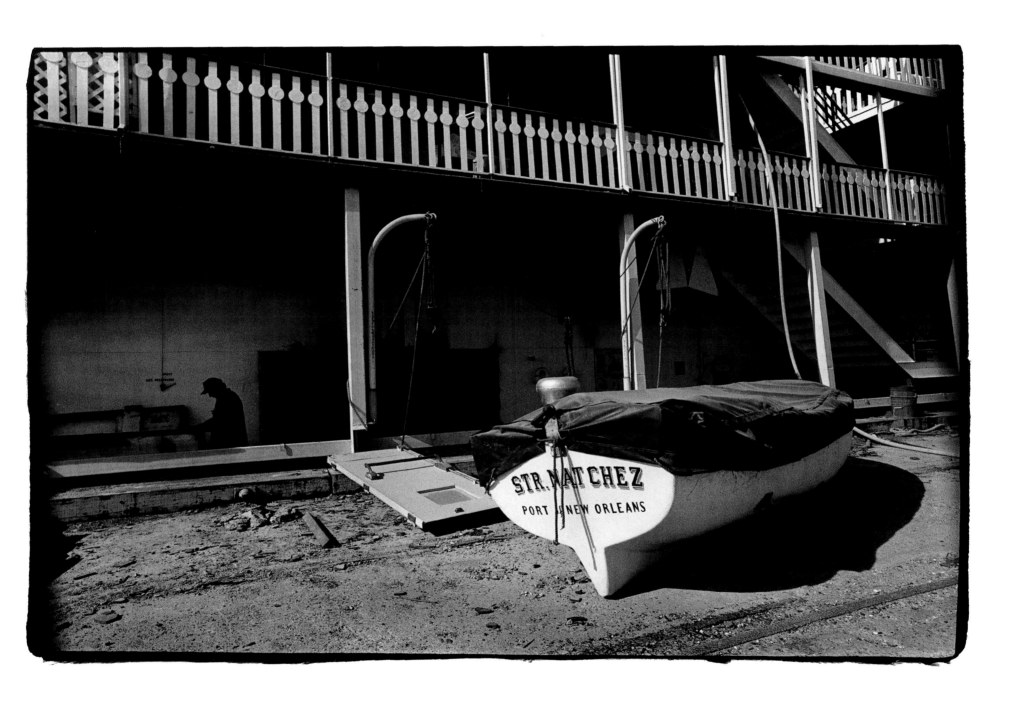

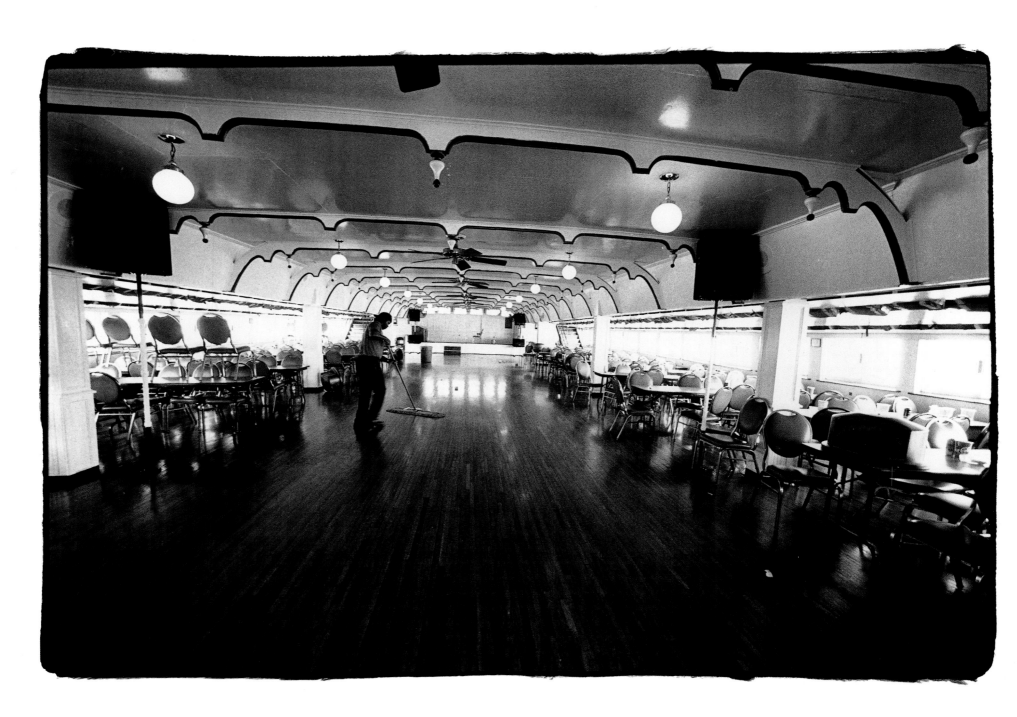

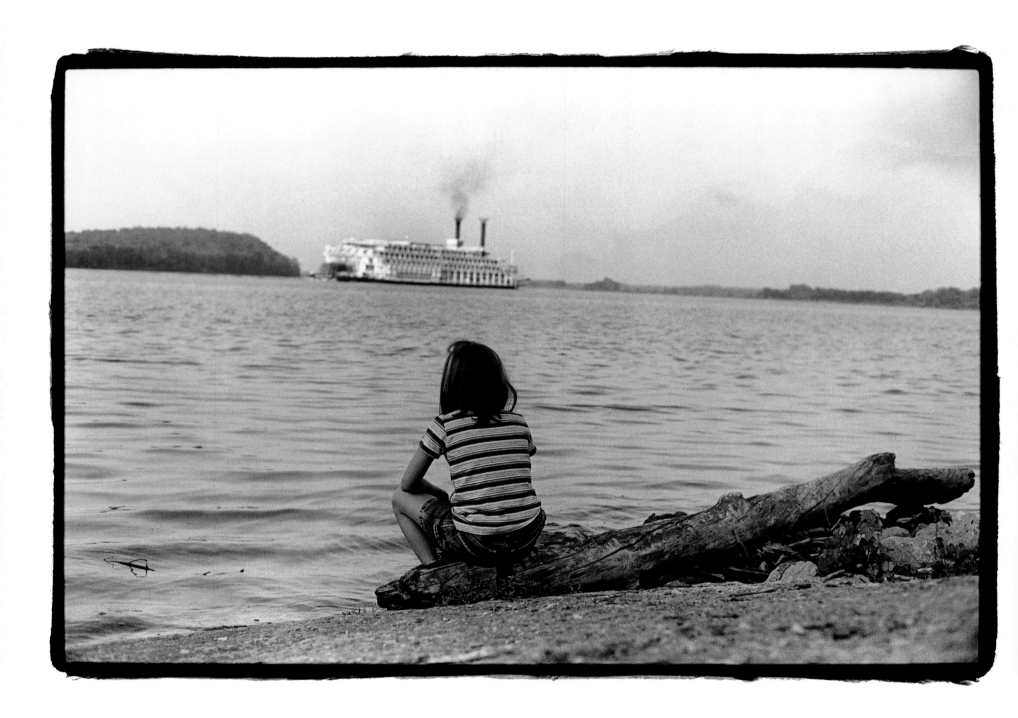

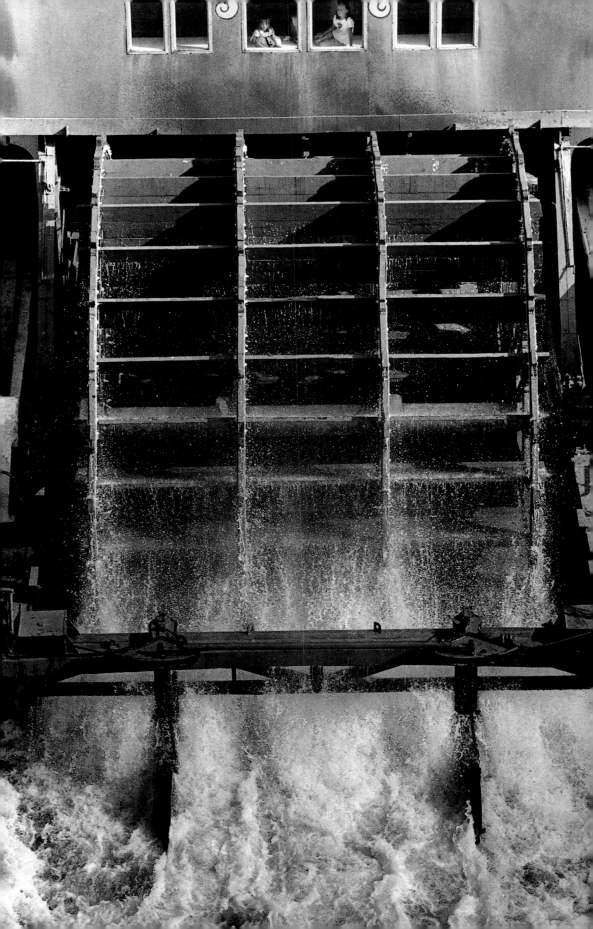

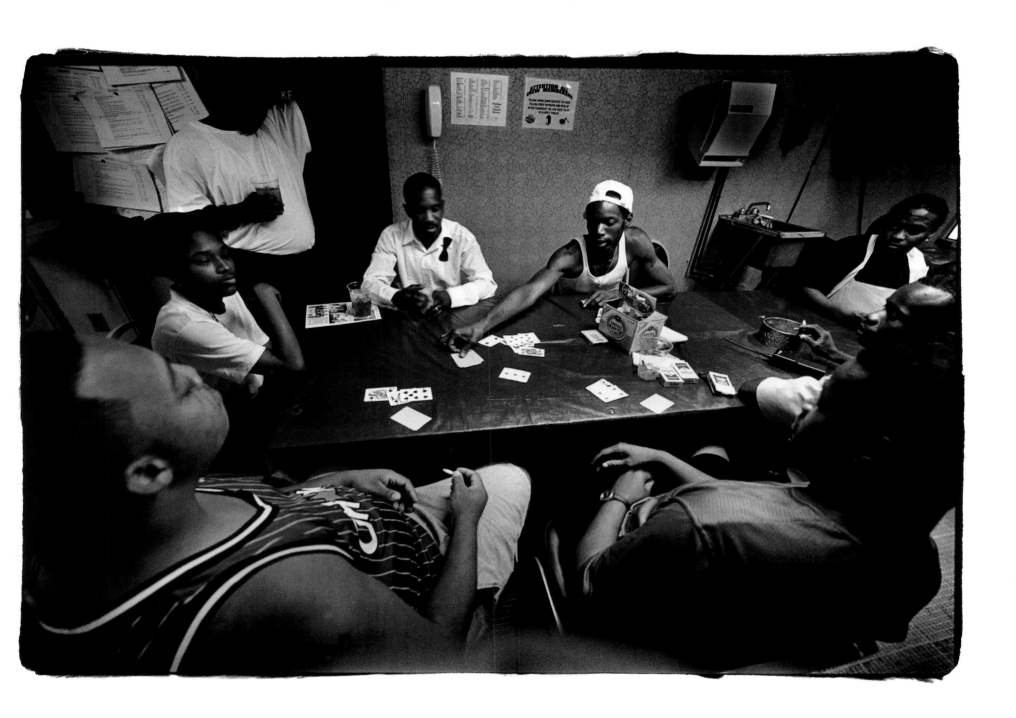

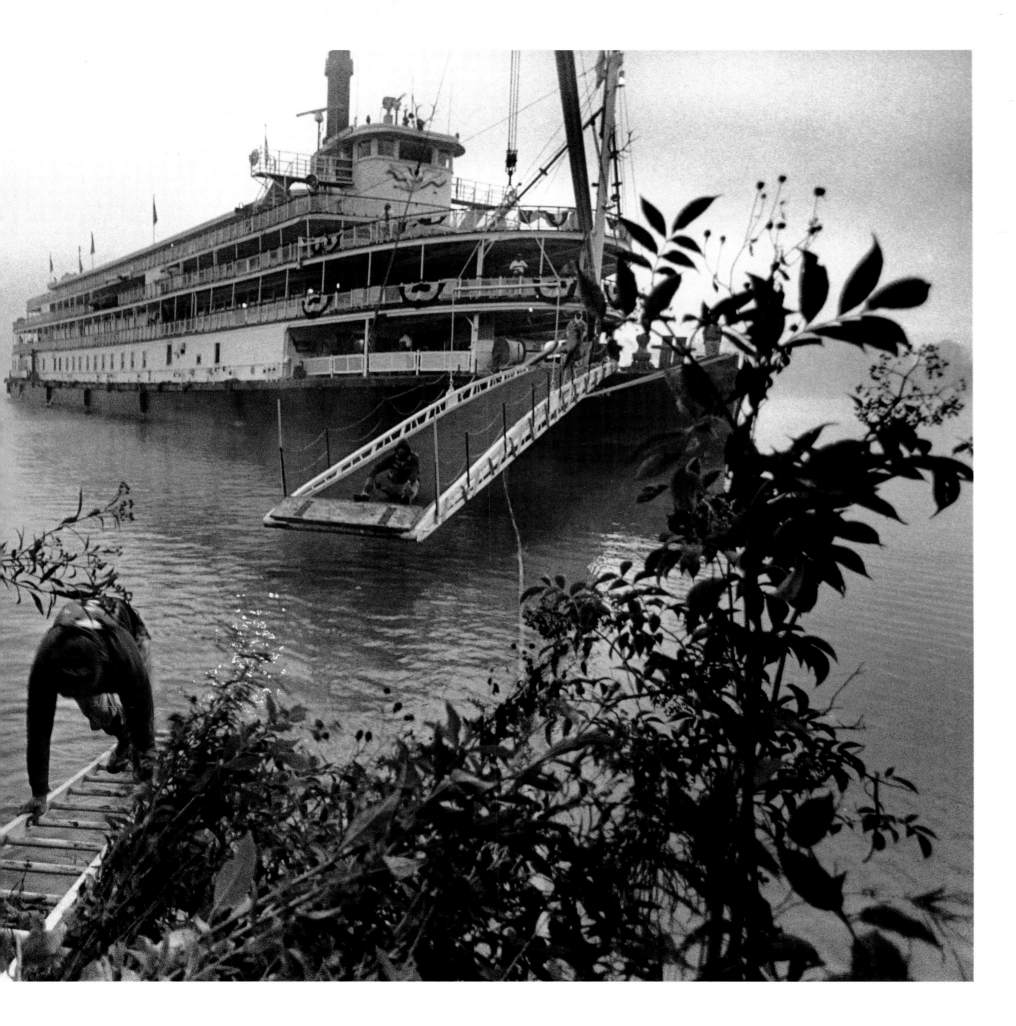

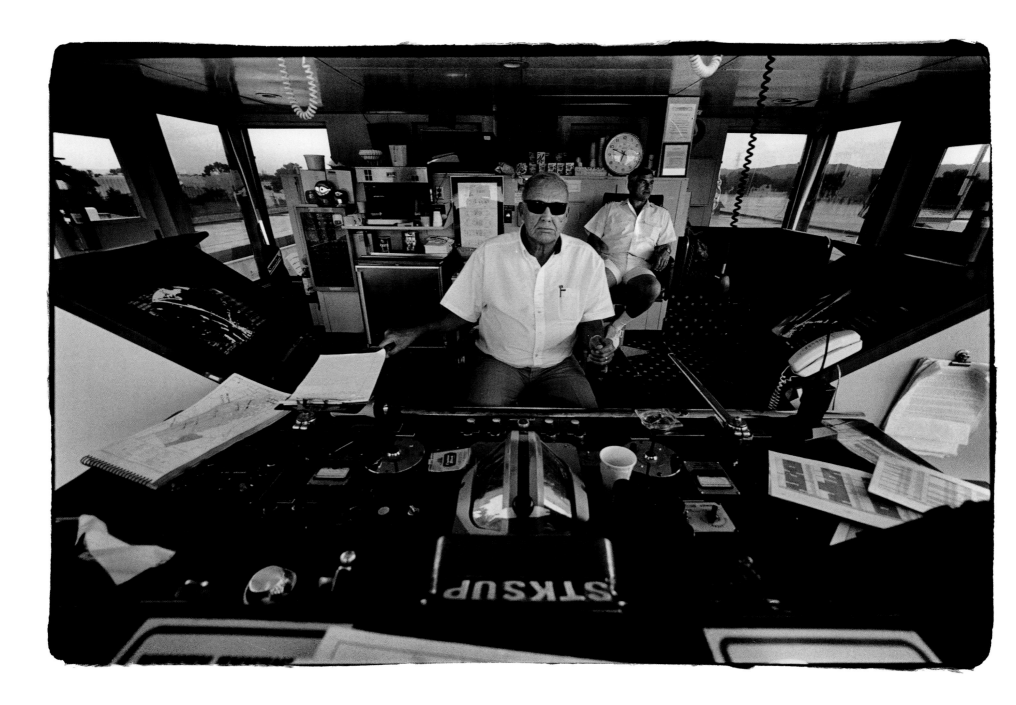

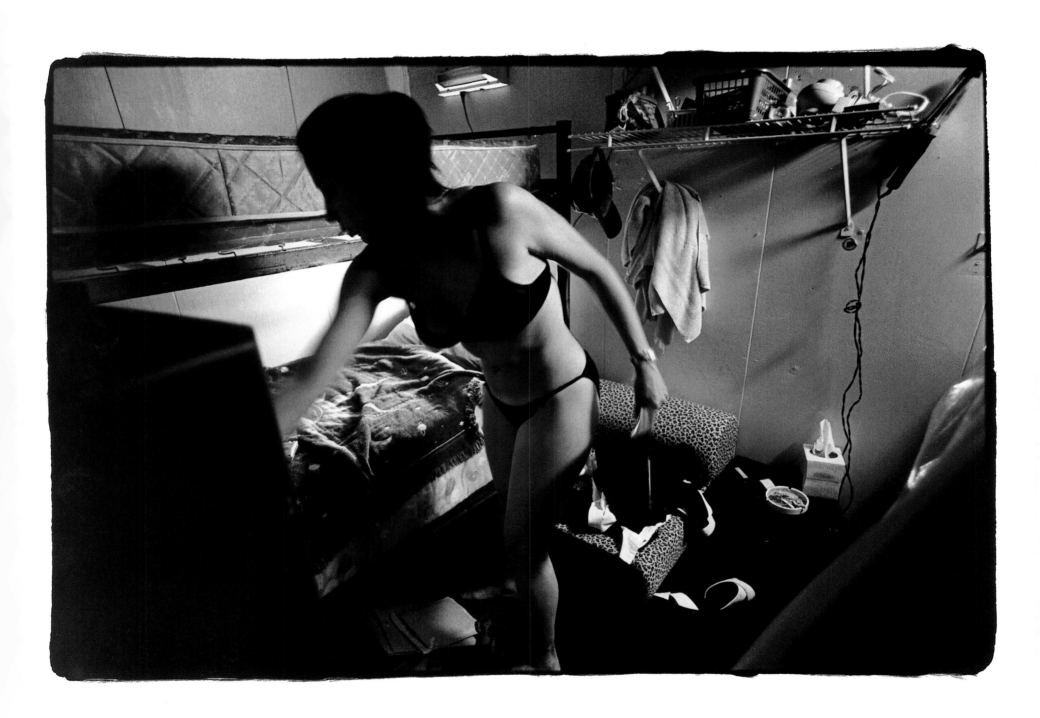

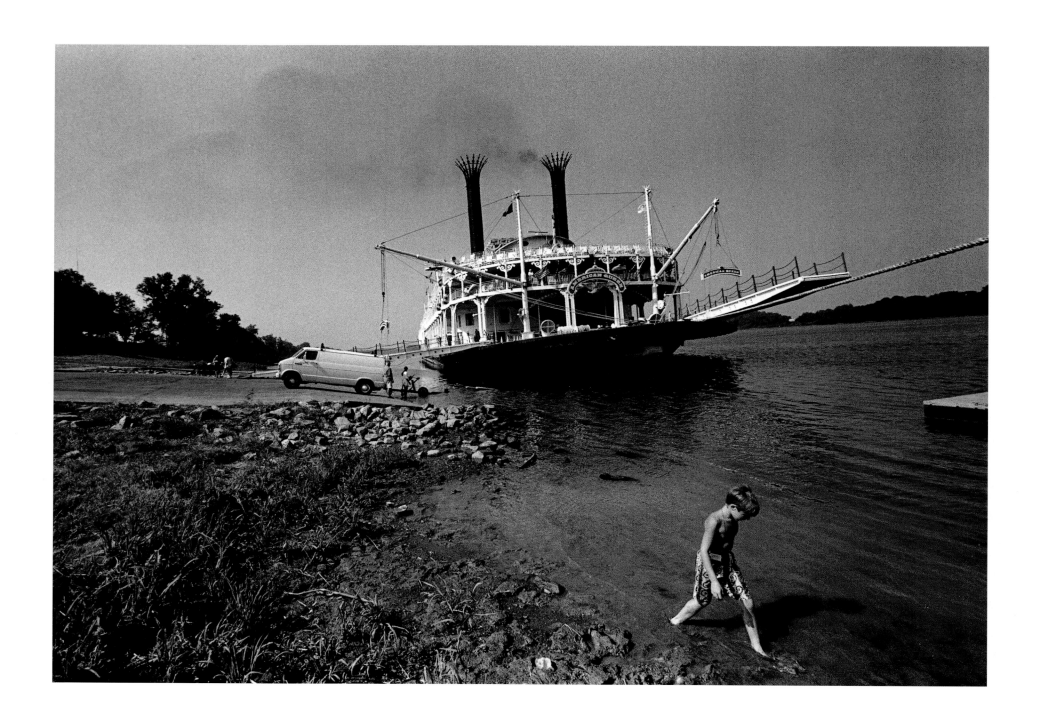

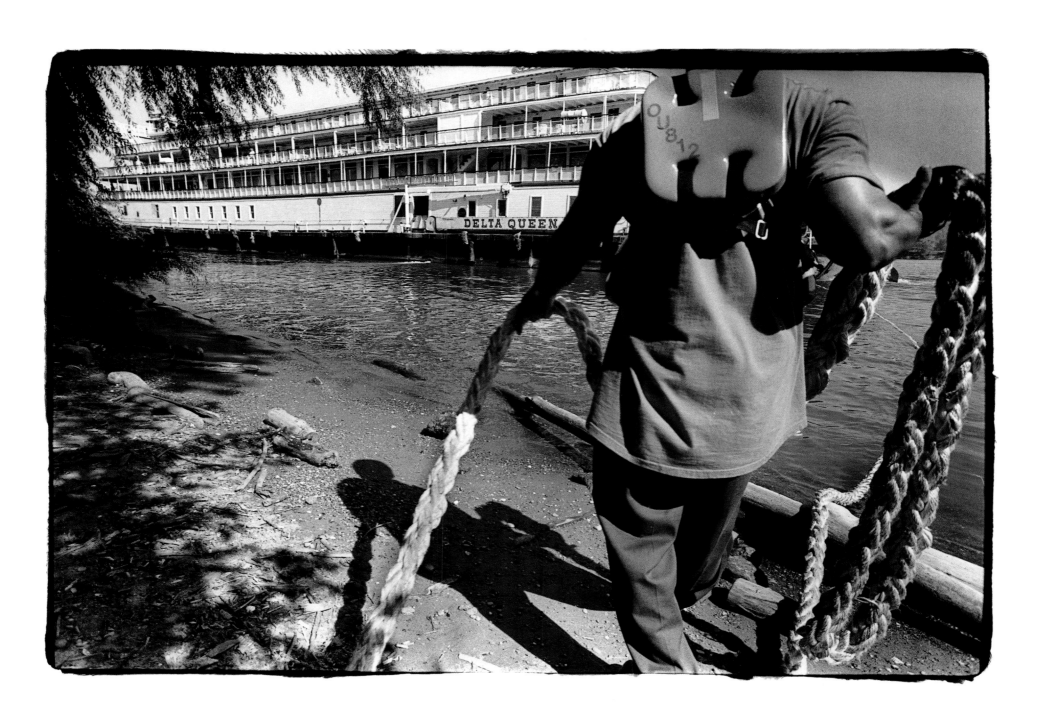

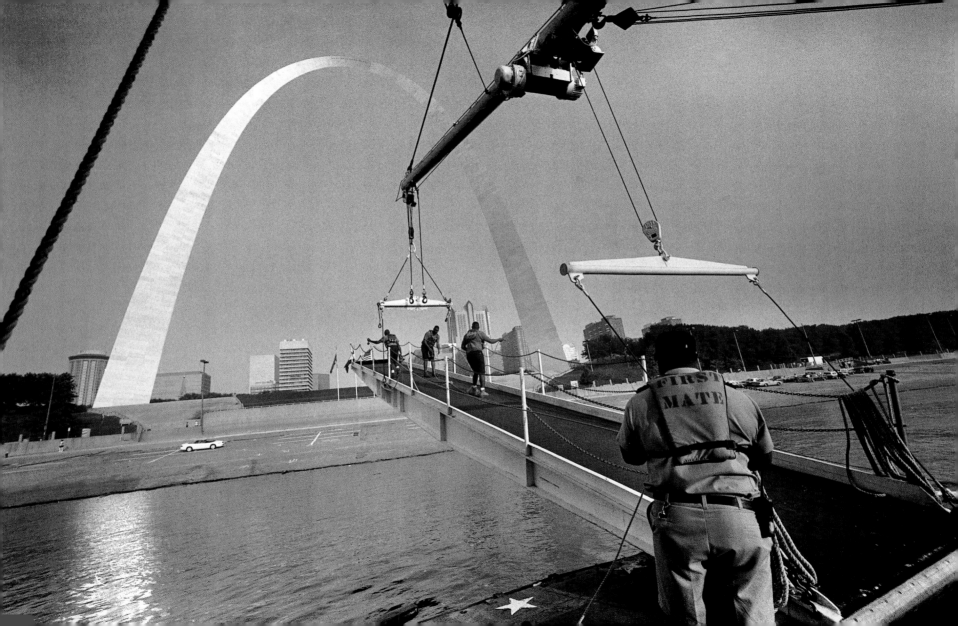

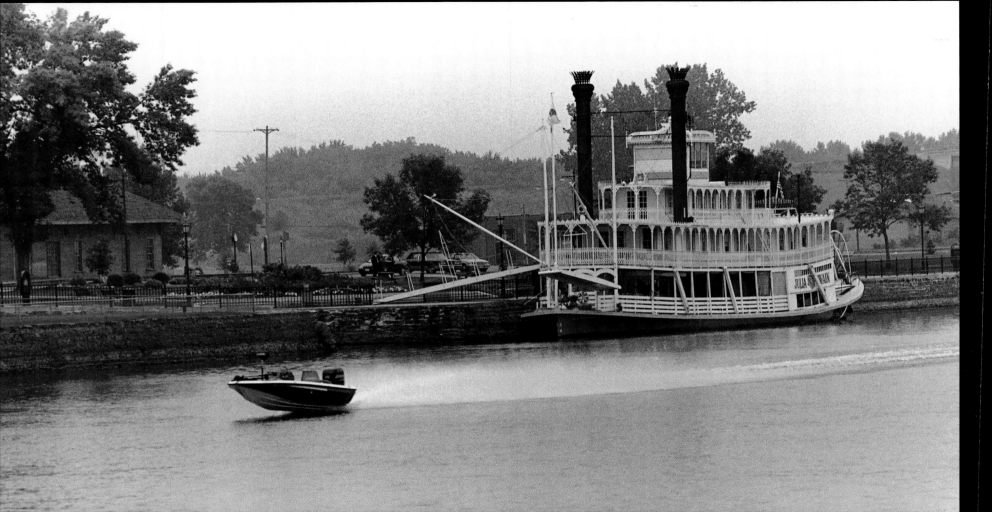

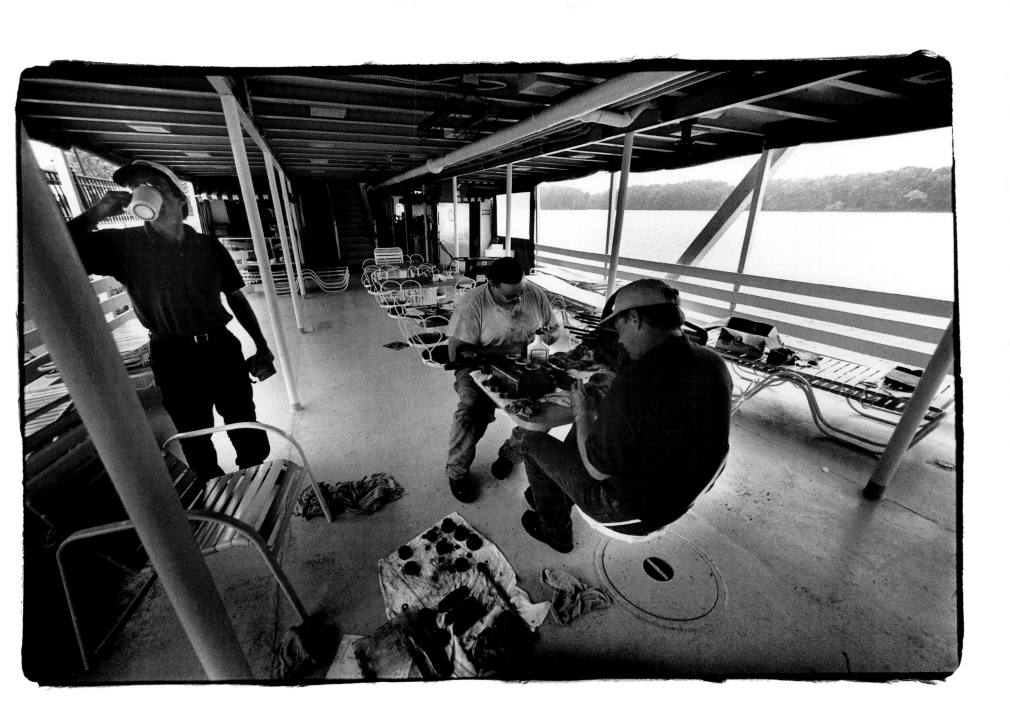

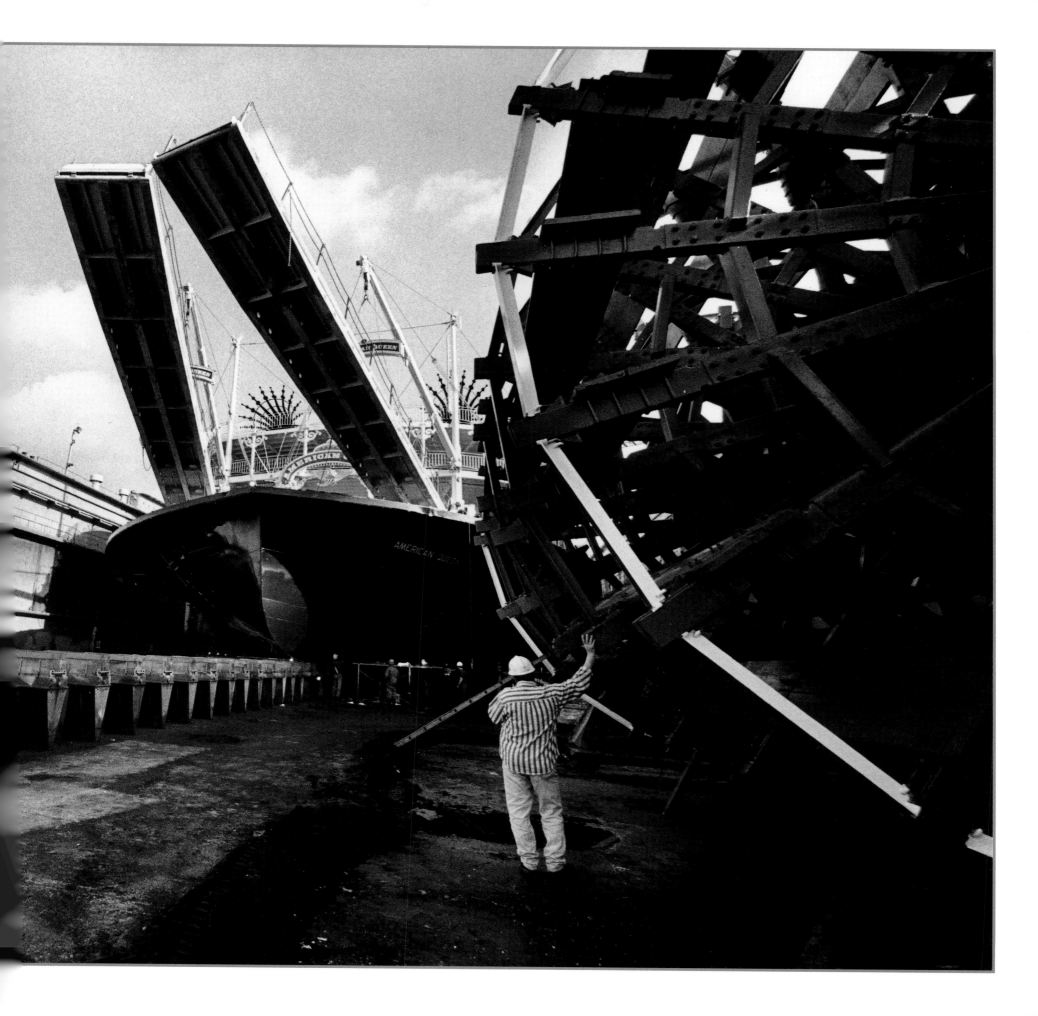

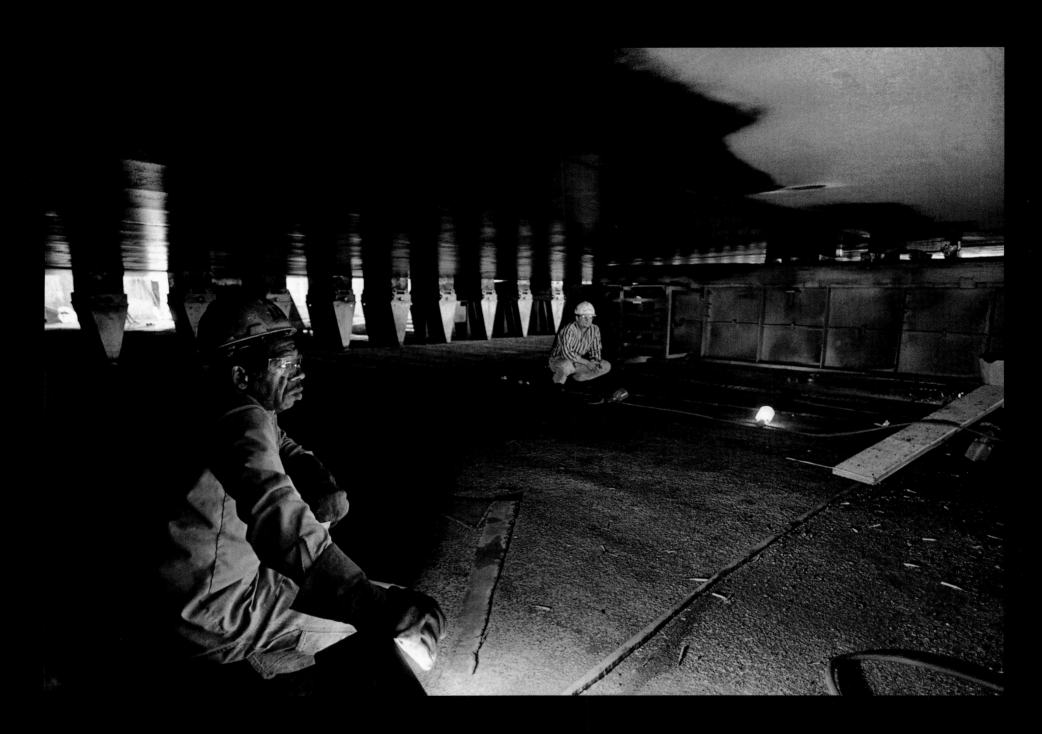

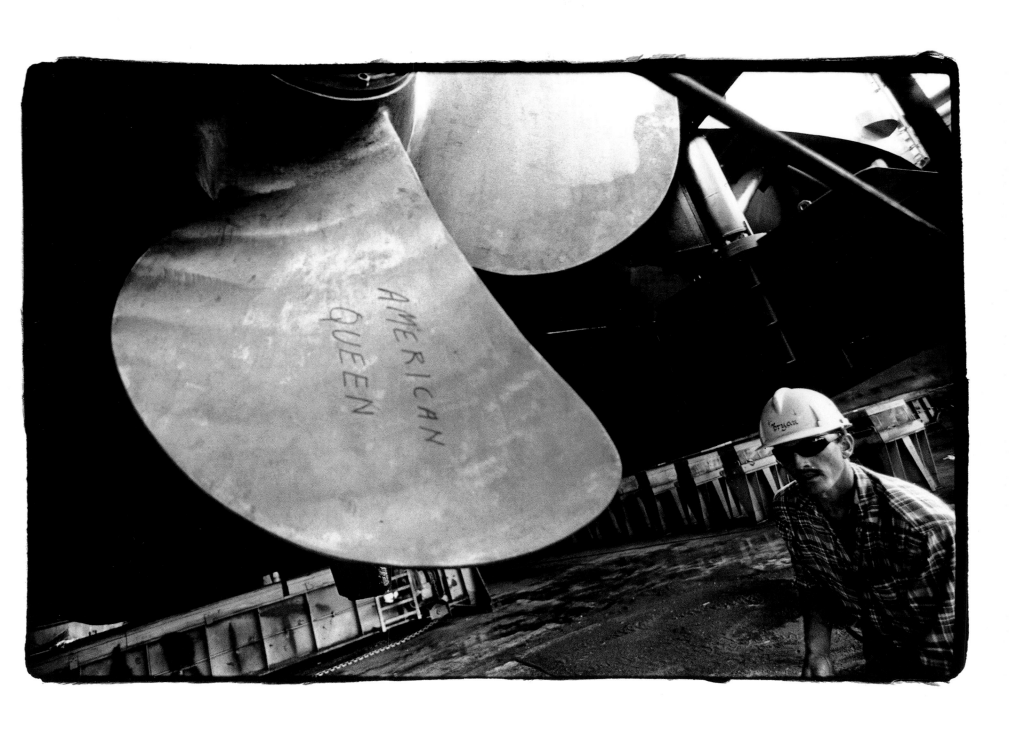

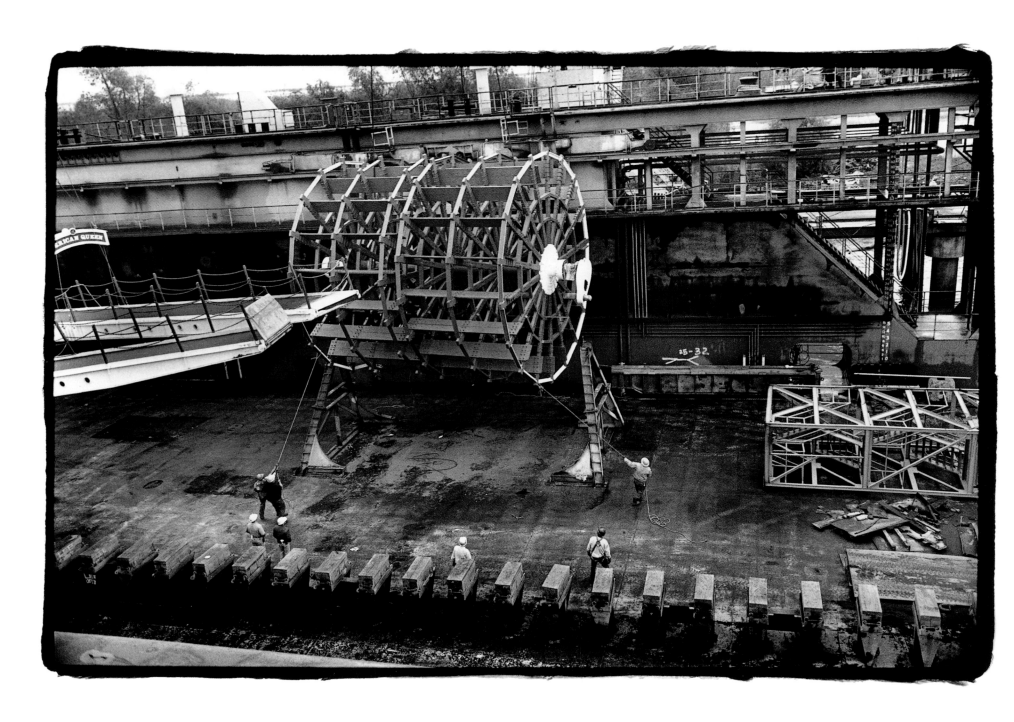

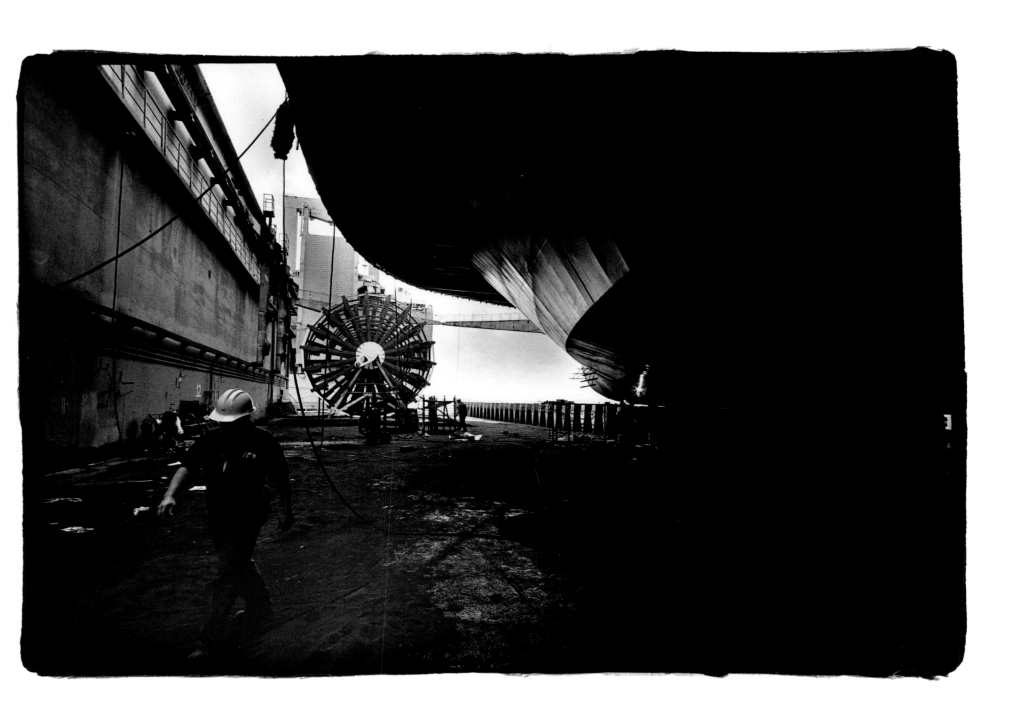

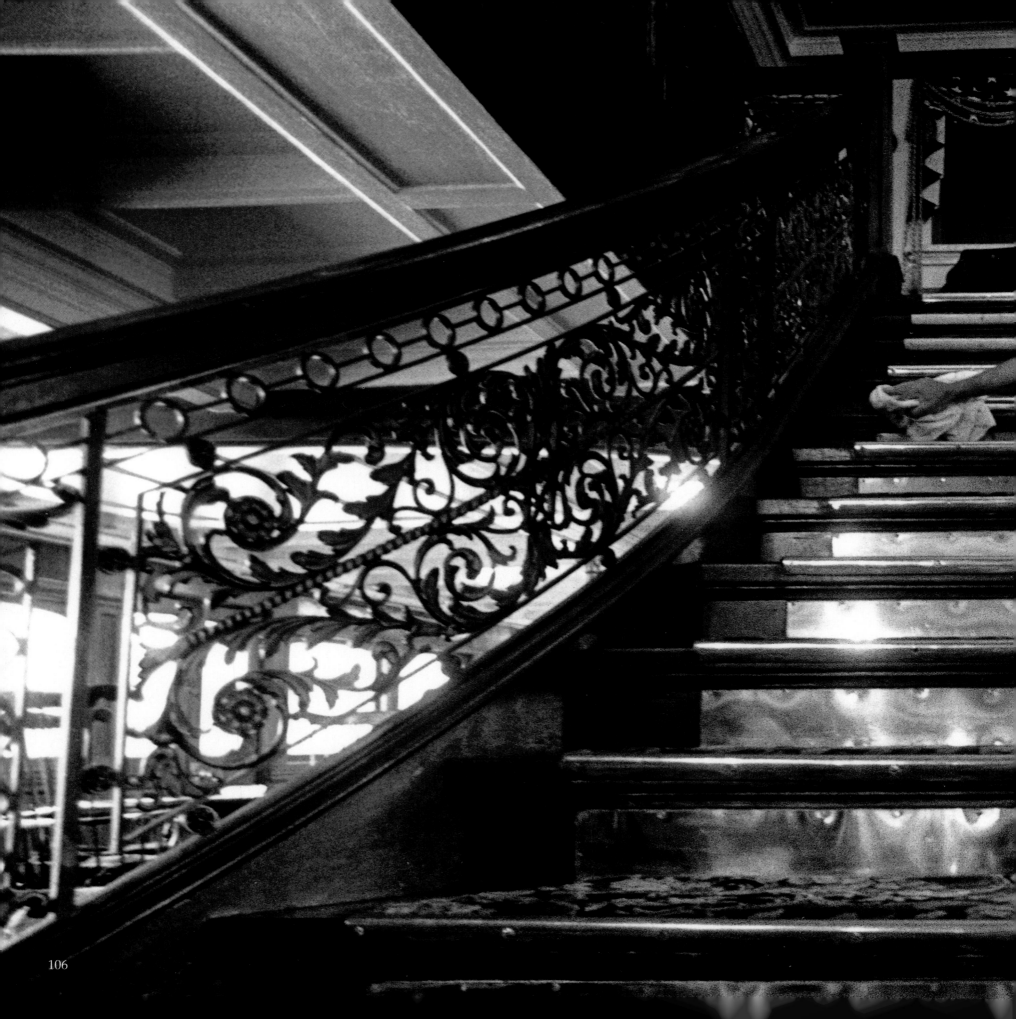

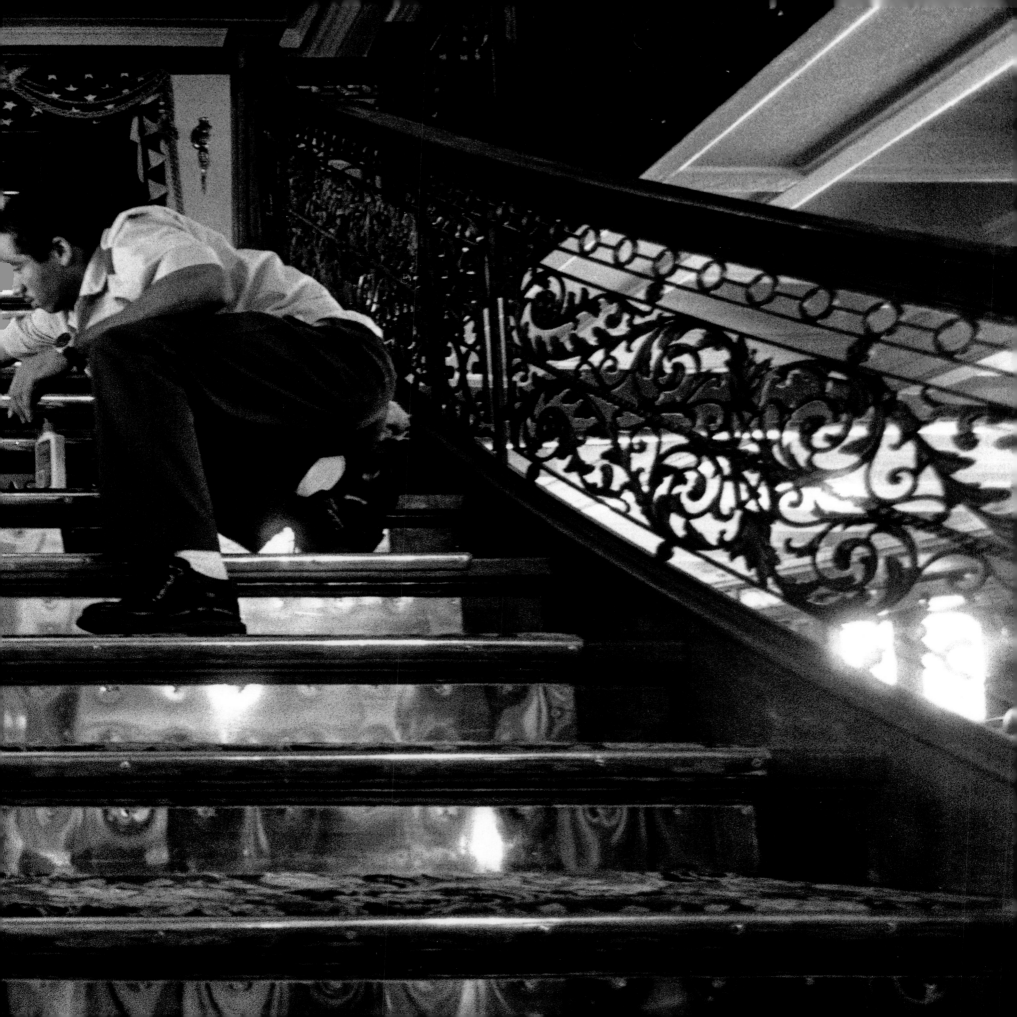

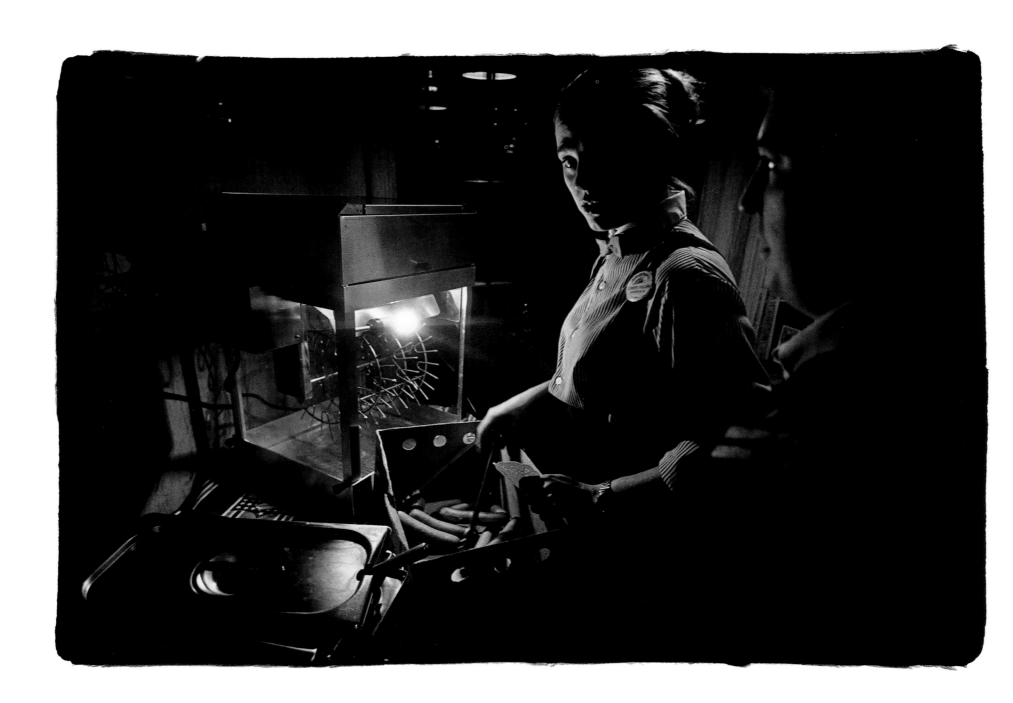

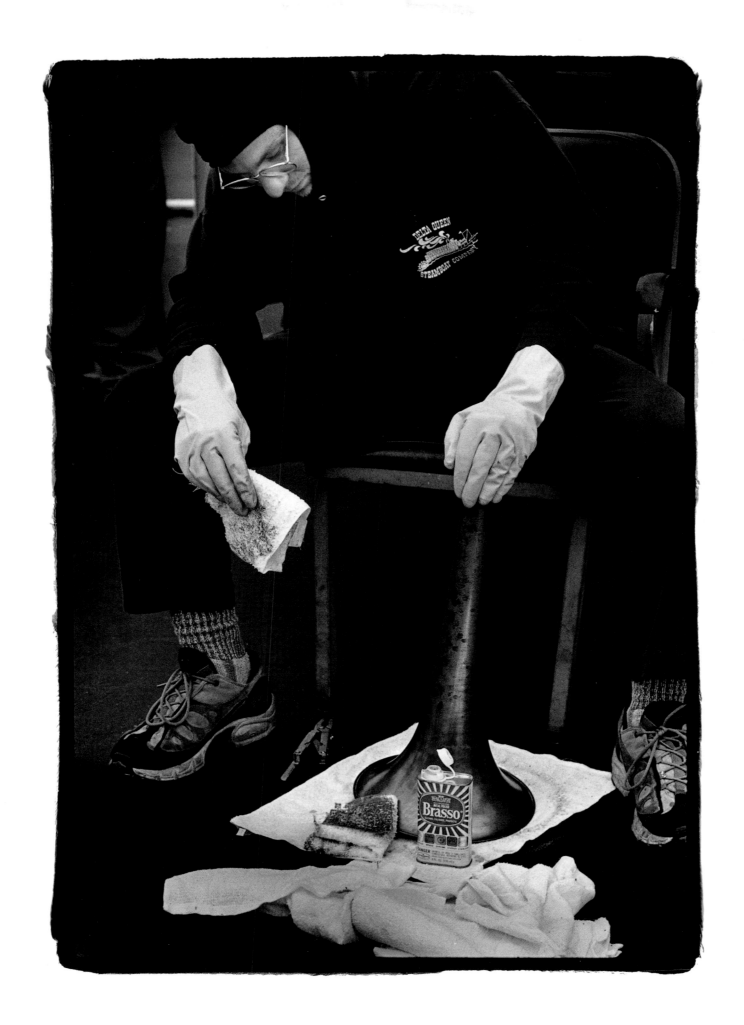

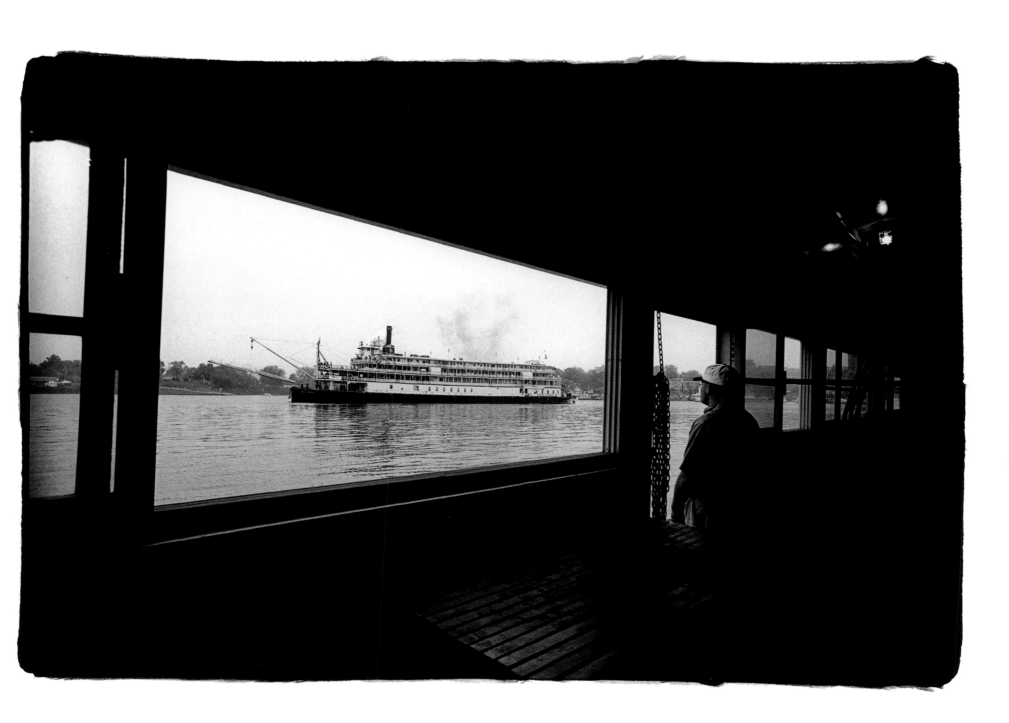

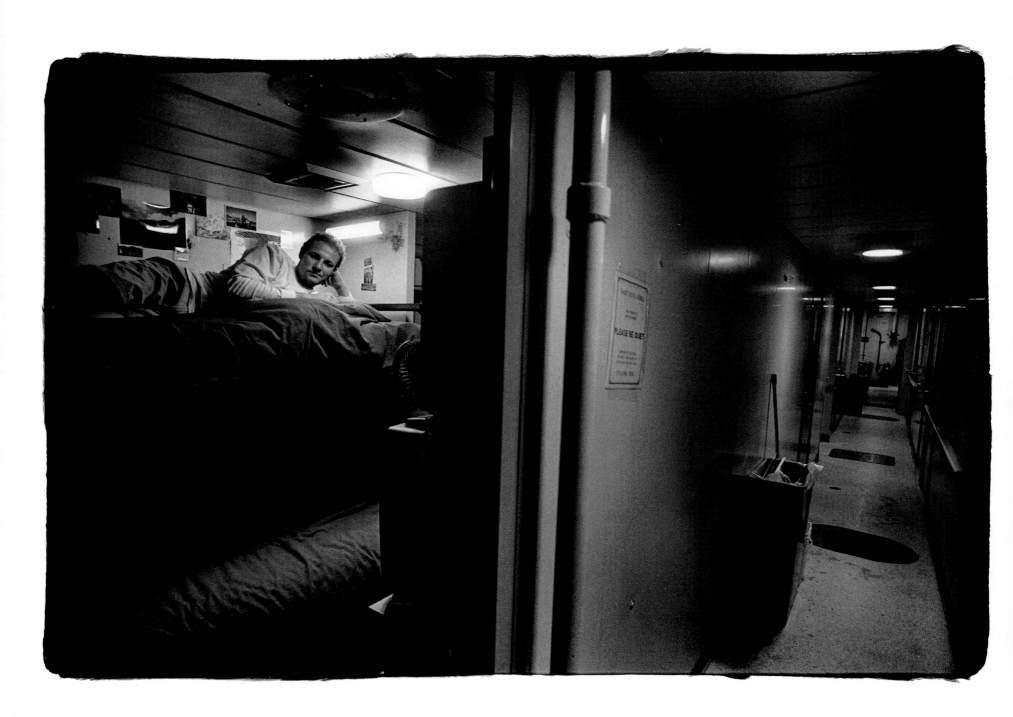

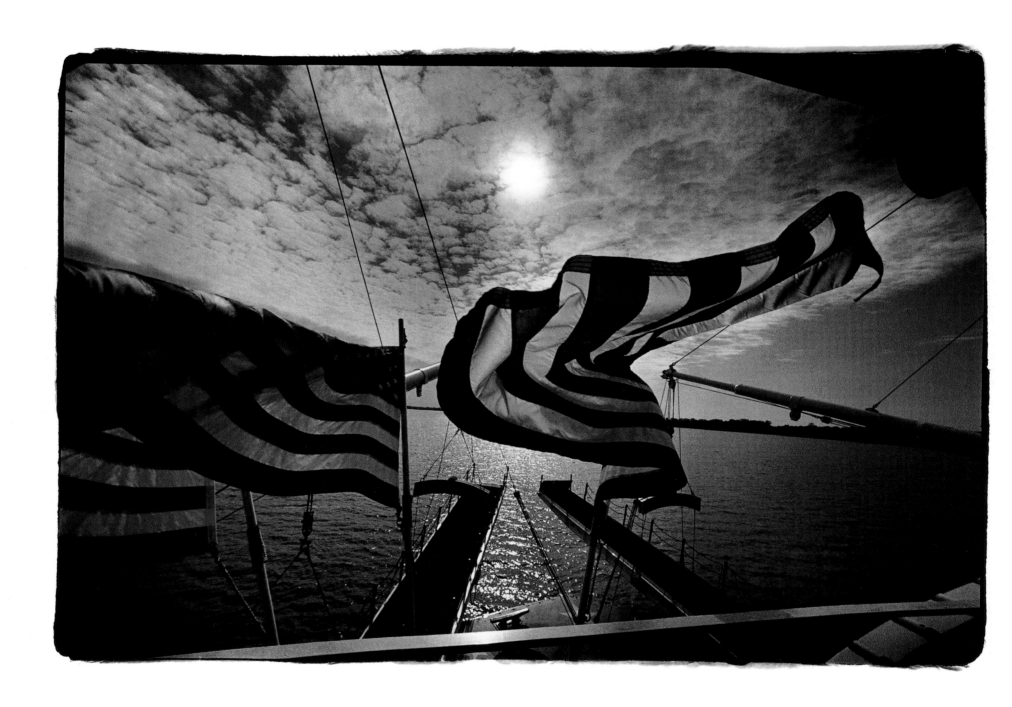

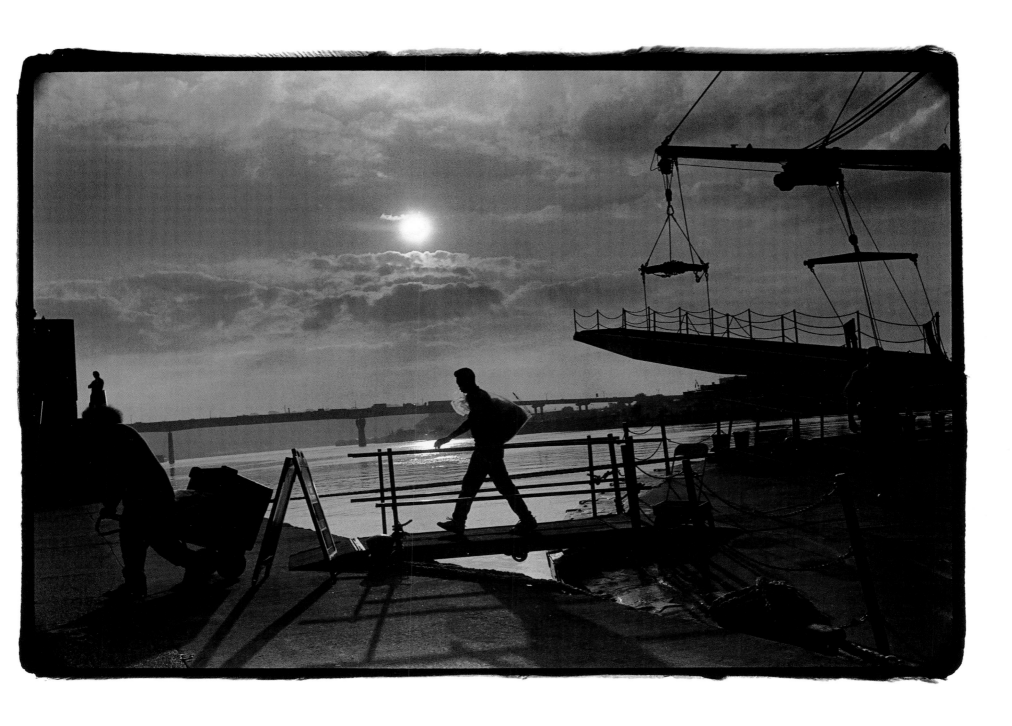

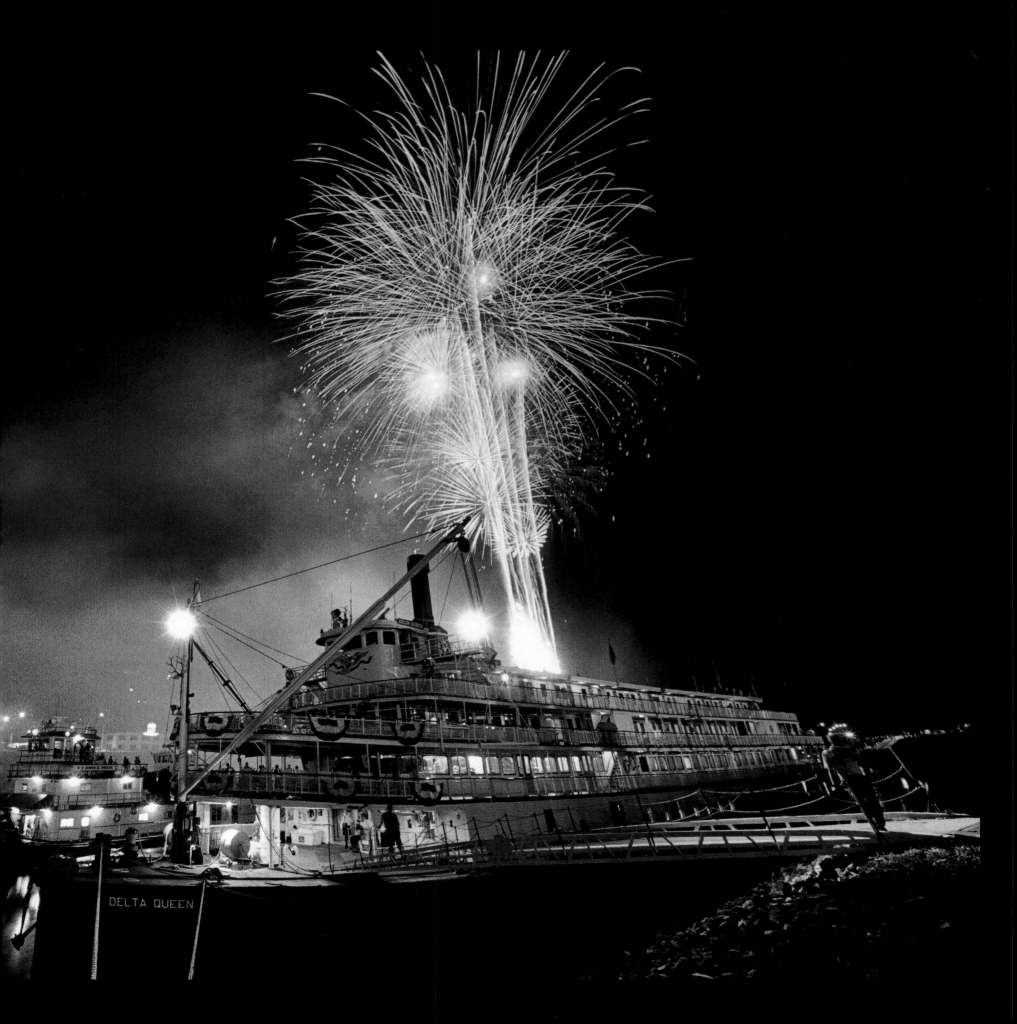

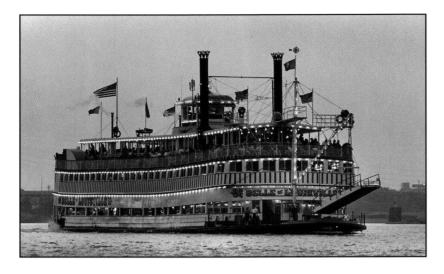

Belle of Louisville , built by James Rees and Sons, Pittsburgh, PA. (Launched as *Idlewild*, 1914, name changed to *Avalon*, 1948, changed to *Belle*, 1962.) Dimensions: 200' x 46', 5'2" draft. Paddlewheel 24'w. x 18' diameter, weighing 17.5 tons. Displacement: 860 tons. Original Rees steam engines over 100 years old. Passengers and crew allowed: 999 passengers, 49 crew. Operated by the Belle of Louisville Operating Board, Louisville, KY.

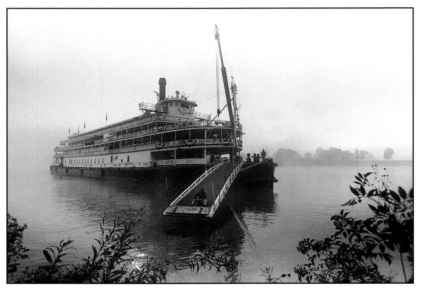

Delta Queen, iron hull and machinery from Isherwood Shipyard, Glasgow, Scotland, 1925. Superstructure built by Evans and Co., Stockton, CA, 1926. Dimensions: 285" x 60', 9' draft. Paddlewheel 19' w. x 28' diameter, weighing 44 tons. Displacement: 1,837 tons. Passengers and crew allowed: 174 passengers, 79 crew. Owner: Delta Queen Steamboat Co., New Orleans, LA.

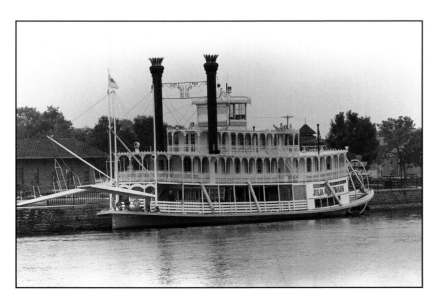

Julia Belle Swain, last boat built by famed Dubuque Boat and Boiler Works, Dubuque, IA, 1971, using Gillett & Eaton steam engines from the ferryboat *City of Baton Rouge*, 1915. Dimensions: 149' x 27', 3' draft. Paddlewheel: 16' w. x 21' diameter. Passengers and crew allowed: 150 passengers, 10 crew. Owner: Great River Steamboat Co., La Crosse, WI.

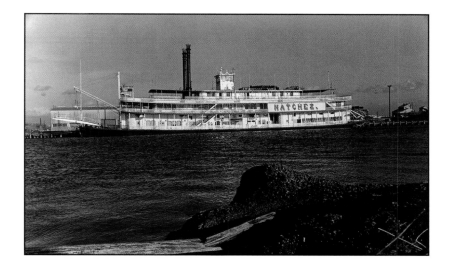

Natchez IX, built by Bergeron Shipyards, Braithwaite, LA, 1975, using steam engines from the U.S.Steel Company's towboat *Clairton,* 1925. Dimensions: 265' x 44', 5.5' draft. Paddlewheel: 24'w. x 25' diameter, weighs 5 tons. Displacement: 1384 gross tons. Passengers allowed: 1,600 passengers, 32 crew. Owner: New Orleans Steamboat Co., New Orleans, LA.

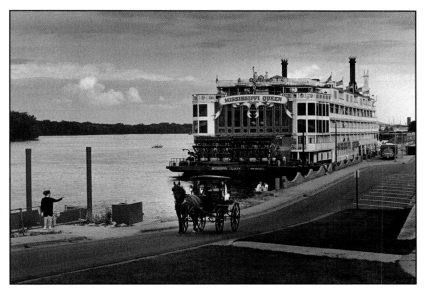

Mississippi Queen, built by Jeffboat Shipyard, Jeffersonville, IN, 1976, with Marietta steam engines originally used in the towboat *Robert F. Brant*, 1929. Dimensions: 382' x 68', 9' draft. Paddlewheel: 36'w. x 22' diameter, weighing 70 tons. Displacement: 4,078 short tons. Passengers and crew allowed: 458 passengers, 165 crew. Owner: Delta Queen Steamboat Co., New Orleans, LA.

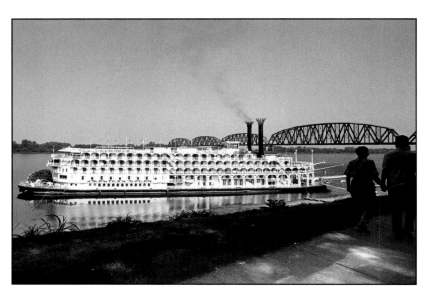

American Queen, built by McDermott Shipyard, Amelia, LA., 1995, using the Nordberg steam engines from the U.S. Corps of Engineers' dredge *Kennedy,* 1932, augmented by 2 Z-drive thrusters. Dimensions: 418' x 89' 4", 8' 6" draft. Displacement: 5,296 long tons. Paddlewheel: 30' w. x 28' diameter, weighing 51 tons. Passengers and crew allowed: 481 passengers, 165 crew. Owner: Delta Queen Steamboat Co., New Orleans, LA.

2. Boarding the *Delta Queen* at Maysville, Kentucky.

5. Deckhand Cesar Lopez.

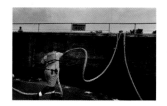

6. First Mate Alan Johnson skill-fully pops a hawser off a lock chamber bollard on the Upper Mississippi.

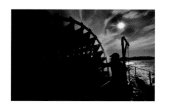

8. Assistant Engineer Jeremie Gates checks the *Delta Queen's* main crankshaft temperature.

9. Bow bitts on the vintage diesel paddlewheeler *"Cotton Blossom"* (originally the U.S. Corps of Engineers' towboat *"Tecumseh"*, 1927) Mobile, AL.

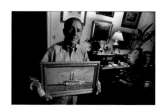

11. Steamboating legend Captain Clarke C. "Doc" Hawley holding a painting of the *Natchez"* in his memorabilia-filled New Orleans living room. During a career spanning 50 years, "Doc" cap-tained five of the six steamers featured in this book and is honored in the National Rivers' Hall of Fame.

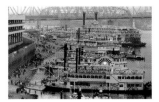

13. At Cincinnati's fabled "Tall Stacks" celebration, the oldest paddlewheel steamer on the river, the *Belle of Louisville* (1914) is moored next to the youngest, the *American Queen* (1995).

14. Poet Roben Jones admires the *Delta Queen* (named a National Historic Landmark in 1970) at the Gallipolis, Ohio landing.

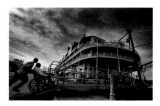

15. Winona, MN landing, *Mississippi Queen*. Note the old sternwheeler *Julius C. Wilkie* pulled up on the bluff for a museum.

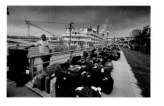

16. Offloading passenger baggage at St. Paul, MN, *Mississippi Queen*.

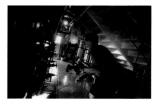

17. Fireman Billy Grounds lights off the oil-fed boilers on the *Belle of Louisville*. It takes the boilers about an hour to build up enough pressure to drive the engines.

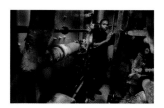

18. Fireman Robert Santee in the *Mississippi Queen's* boiler room, providing steam for her vintage 1929 Marietta engines, originally used in the towboat *Robert F. Brant*.

19. The luxurious *J. M. White* Dining Room on the *American Queen*.

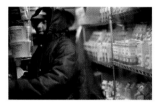

20. Ron Banks stowing ships' stores on the *Mississippi Queen*.

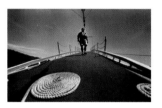

21. 19-year veteran First Mate Larry "Buford" Wilkinson inspecting the *Delta Queen's* landing stage.

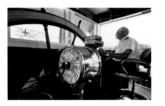

22. 74-year old pilot Captain Charles "Bud" Decker (54 years on the river, with 18 on the *Belle*) takes the *Belle of Louisville* out into the Ohio River.

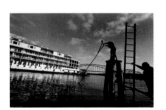

23. Casting off from Dubuque, IA.

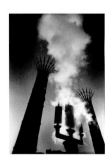

24. Steam whistle of the *American Queen* at full cry.

25. First Assistant Engineer Tadeusz "Tad" Kornecki at the throttle of the *Delta Queen 's* 1925 steam engines. A hand-counted 12 rpm's of the paddlewheel (about 8 mph) is normal speed.

26-27. The *American Queen* "running with a bone in her teeth".

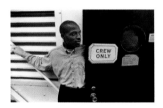

28. Jermal Johnson checks out a departure.

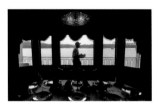

29. *Mississippi Queen*.

30. Dining Room Captain Anthony Lewis demonstrates his presentation skills.

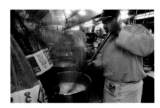

31. Sous chef Frederick Payton in the *Mississippi Queen's* galley. The galley prepares an average of 1,656 meals per day.

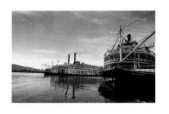

32. First Mate "Buford" Wilkinson observes the *American Queen* maneuvering.

33. Decorative mermaids, bathed in the steam of the *Mississippi Queen's* calliope (pronounced cally-oap by old-time steam-boaters), bid farewell to St. Paul, MN.

34. Ubiquitous rockers: *Mississippi Queen.*

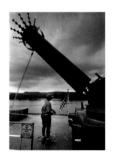

35. Deckhand Eric Morgan preparing for a low bridge on the *Mississippi Queen.* 84 year-old Captain Charles Stone of Point Pleasant, W. VA. reminisced that "it used to take us all day to get the stacks down" in the old days, when they were not cantilevered, but permanently rigged with screws.

36. Passenger Perez Collins plays solitaire under watchful eyes aboard the *Delta Queen.*

37. Bassist James Fowler of the *Delta Queen's* " Riverboat Five".

38. Silhouetted by his spotlight, Pilot Captain Harold Schultz stands a graveyard watch. (Capt. Schultz also does a mean Elvis impression.)

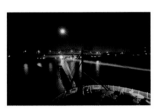

39. *American Queen* picking her way down river.

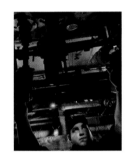

40. Fireman Charles Meeks in the *Delta Queen*'s boiler room. On the river, the boiler room is referred to as the "firebox".

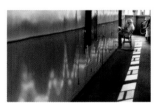

41. *Belle of Louisville* fireman Wayne McDole at his firebox post after 13 years on the *Belle.*

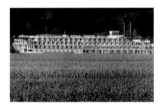

42-43. *American Queen* slides past a Kentucky cornfield on the Ohio River.

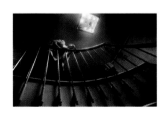

44. Keeping the brightwork bright on the *Mississippi Queen.*

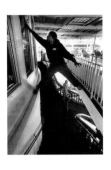

45. Delaware Stokes cleans up the view for passengers on the *American Queen*.

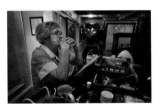

46. *Belle of Louisville 's* main staircase, reflecting her unfettered "work boat" heritage. She started life as a car ferry, the *Idlewild* in 1914.

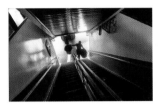

47. Taking a brief break, stateroom attendant Ellie Downen ("12 years on this deck") reminisces about her brushes with the ghost of the *Delta Queen*.

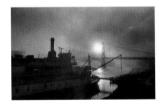

48. Foggy morning on the Ohio River: the *Delta Queen* at Maysville, KY.

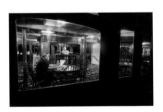

49. At the end of another midnight shift, First Assistant Engineer Tadeusz Kornecki relaxes in the *Delta Queen's* main lounge. A lifelong sailor, he jumped ship from a Communist freighter in 1982 in New Orleans and found a new home on the *DQ*.

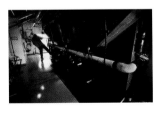

50. Fireman Wayne McDole kicks flame bed door shut on one of the three massive Nooter boilers of the *Belle of Louisville*. The boilers develop 175 pounds of steam pressure for her two James Rees & Sons engines.

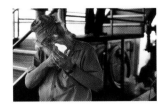

51. Twenty-seven years on the *Belle of Louisville*, Engineer Mike Pfleider endures engine room temperatures that routinely top 150 degrees in the summer months. In August, 1999, while shooting this book, the temperature passed 175 degrees, a new record on the *Belle*.

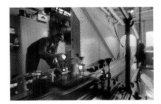

52. Asst. Engineer Jeremie Gates lubricates a moving pitman arm on the *Delta Queen*.

53. Tools of the trade.

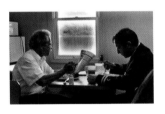

54. Bar Manager Tracy Galjour (r.) shares a moment of solitude with watchman Stephen Kovac.

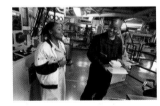

55. Newlywed *American Queen* crewmembers Tyanna Robinson and Third Assistant Engineer Bobby Williams share an engine room smile.

56. Edward Phipps feeds the voracious incinerator on the *American Queen*.

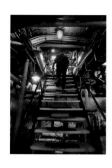

57. Oregon spruce-planked deck identifies the lower engine room of the *Delta Queen*, built in 1927.

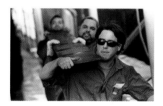

58. Captain Edward G. "Pete" O'Connell emerges from a routine *Belle of Louisville* bilge inspection.

59. Deckhands Mark Farley and Tim Webb manhandling a solid steel rub rail on the *American Queen*. The top clamps on the rub rails are sheared off constantly by the rough concrete walls of lock chambers.

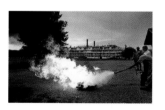

60. Under the watchful eyes of SIU Fire Instructor Anthony Hammett, *Mississippi Queen* deckhand Thomas Harris practices a fire drill on the Prairie du Chien, WI landing.

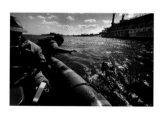

61. In the cold October waters of the Ohio River at Paducah, KY, deckhand Dewey Bullock waits to be rescued in an *American Queen* "man overboard" drill.

62. Entertainer Walter Kross conducts an informal practice session in his *DQ* quarters.

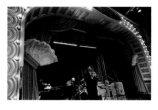

63. The fancy proscenium stage of the *American Queen*.

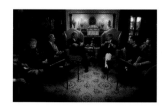

64. *American Queen* Captain John P. Davitt (l.) presides over Captain's Dinner cocktails.

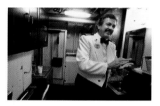

65. Captain Gabe Chengery cleans up after a Captain's Reception aboard the *Delta Queen*.

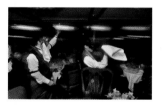

66. Dining Room Captain Janet Babio leads the "second line" procession, a time-honored New Orleans tradition, through the *Mississippi Queen's* main dining room on the last night of each cruise.

67. Partition (pastry) chef Raheem Flowers.

68. Kellie Clark up to her elbows in the *Mississippi Queen's* ship's laundry.

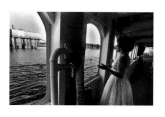

69. Entertainer Paula Betlem warms up with a power plant serenade on the *American Queen*.

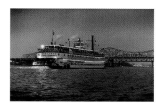

70. Designated a National Historic Landmark in 1989, the *Belle of Louisville* moves off on another evening cruise.

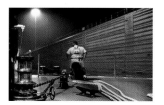

71. Straddling the hawsepipe, Second Mate Johnny Speed relaxes as the *Mississippi Queen* enters a lock chamber.

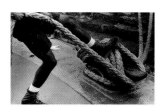

72. The traditional river term for a cleat is a "kevel".

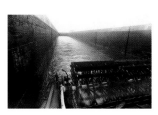

73. Foggy lock chamber on the Upper Mississippi River, one of 29 between St. Paul and St. Louis. Deckhand Raymond Gordon stands watch on the fantail of the *Mississippi Queen*.

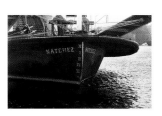

74. *Natchez* in layup in the Ship Channel, New Orleans. Based in this tourist mecca, the *Natchez* has been ridden by more passengers than any other American steamboat in history, over 12 million people!

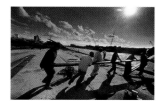

75. Captain Steve Nicoulin and crew replacing heavy white oak bucket boards on the *Natchez'* sternwheel.

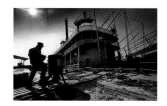

76. Sandblasting the *Natchez*.

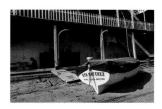

77. Captain Nicoulin, a 25-year *Natchez* veteran, inspects cutaway bulkheads in preparation to replace one of the her original 1975 boilers.

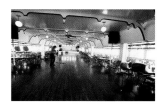

78. Sweeping up the most popular dancefloor on the Ohio River aboard the *Belle of Louisville*.

79. Damp morning.

80. Alexa Black daydreaming on the Carrsville, KY landing. *AQ* in the distance.

81. Best seat in the house for the Great Steamboat Race at the Tall Stacks Festival, Cincinnati.

82. Waiter Gary Garrety admires the Upper Mississippi River scenery from the open-air crew gym.

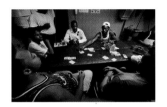

83. Irvin Richardson throws in his cards, after hours in the *MQ* crew's mess.

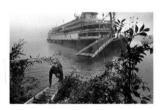

84-85. Deckhand Juan Baptiste retrieves the shore line after a night of "choking a stump" (mooring to a tree on shore). *Delta Queen*.

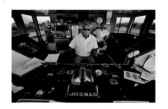

86. No wheel in this wheelhouse. Capt. Gene Tronier, a pilot for 43 years, steers the *Mississippi Queen* with rudder bars under the watchful eye of Ship's Master, Captain Paul Thoeny.

87. The scourge of all tall-stacked steamboats on the Mississippi River system. Louisville, KY.

88. Crew Quarters

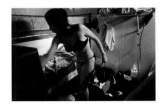

89. No space goes unused in the compact quarters of bartender Susanne Giliberti on the *Delta Queen*.

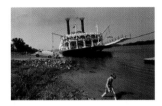

90. 8 year-old Colt Denton cools off in the Ohio River oblivious to the *American Queen*. Henderson, KY.

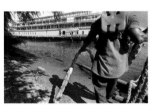

91. Picking up the stern line.

92-93. Looking for a big enough stump to choke.

94. Monkey fist and heaving line.

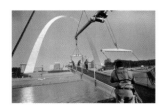

95. Readying the stage for landing.

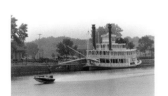

96. The *Julia Belle Swain* at historic Prairie du Chien, WI.

97. The classicly-styled wheel-house of the *Julia Belle Swain*, widely admired as the finest example of the Western Rivers sternwheel packets that worked the Upper Mississippi over 130 years ago.

98. Senior Captain Neil Conklin concentrates on a broken feed water pump on the *Julia Belle Swain*. Although built in 1971, the *Julia Belle* is powered by steam engines off the 1915 ferry *City of Baton Rouge*.

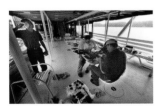

99. Mate Lee "Fatboy" Havlick takes a refreshment break as Captain Neil Conklin and deck-hand Steve Nelson ponder their next move in repairing a vintage pump on the *Julia Belle Swain's* open first deck.

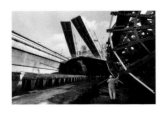

100-101. High and dry, the *American Queen's* 90 foot beam fits comfortably into her drydock at Litton Industries' Avondale Shipyard near New Orleans.

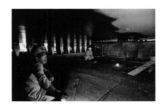

102. Welder Donald Roussel and Drydock Mechanic David Rillieux directly underneath "the bateau", the 3,707-ton *American Queen*, in drydock.

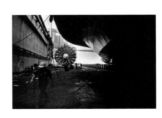

103. The massive *American Queen*, largest inland river steamboat ever constructed, continues the tradition of augmenting the power of it's paddlewheel with propeller assistance. Such motive arrangements have been used by many steamers, primarily ocean going ships, such as the *Great Eastern*, Brunel's huge ship that laid the first Trans-Atlantic cable.

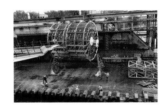

104. Lifting the *American Queen's* 51-ton sternwheel for refitting.

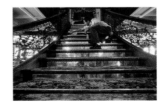

105. Chief Engineer "Pete" Jordan makes an inspection tour of the *AQ* in Avondale Shipyard's Panamax drydock. Steamboats are routinely required by the Coast Guard to be hauled into drydock once every five years.

106-107. Porter Herman Robinson polishes the brass kickplates on the *Delta Queen 's* grand staircase.

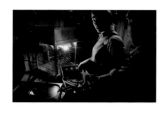

108. The hot dog machine reminds bartender Christy Phillips of a sternwheel.

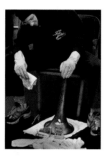

109. Lead Deckhand Hunter Smith puts a shine on the *American Queen's* fog horn.

110. Payday.

111. Observing the *Delta Queen* maneuvering for a landing at Cincinnati from the *Belle of Louisville's* engine room.

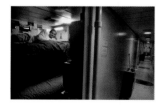

112. Hunter Smith studying for his Mate's examination. Crew Quarters, *American Queen*.

113. Jeremie Gates handling routine maintenance.

114. River breeze greets the *American Queen*.

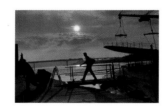

115. "Turnover Day" on the *Mississippi Queen*.

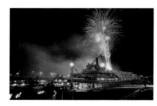

116-117. Fireworks finale salute to the participants of the annual Steamboat Regatta at Charleston, WV.

The photographs in this book were taken with Leica M6 camera bodies using a variety of lenses. All were taken with available light using Kodak Triax 400 ASA film. Jon Kral would like to express his thanks to Leica for the loan of some of the camera bodies and lenses used in this production.